The Little Things

A Coloring Book of Plants and Creatures
For the Beginner Grayscale Colorist.

ERIKA S. CLARK

DEDICATION

To my mother who kept pushing the creative part of my brain and to my husband who has allowed me to follow the bats in my attic.

I love you.

Copyright © 2012 Erika S. Clark

All rights reserved.

ISBN: 1535327235

ISBN-13: 978-1535327235

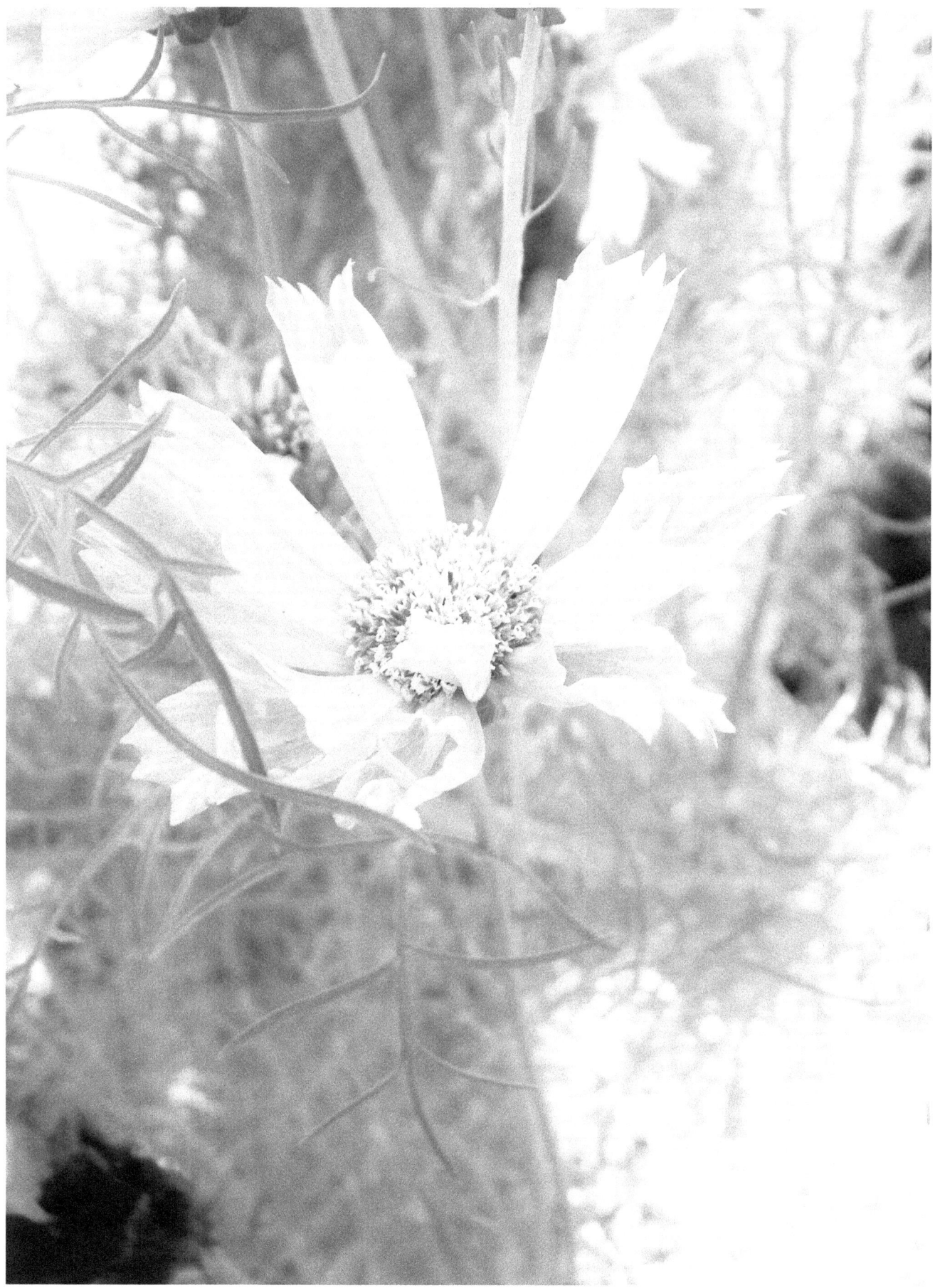

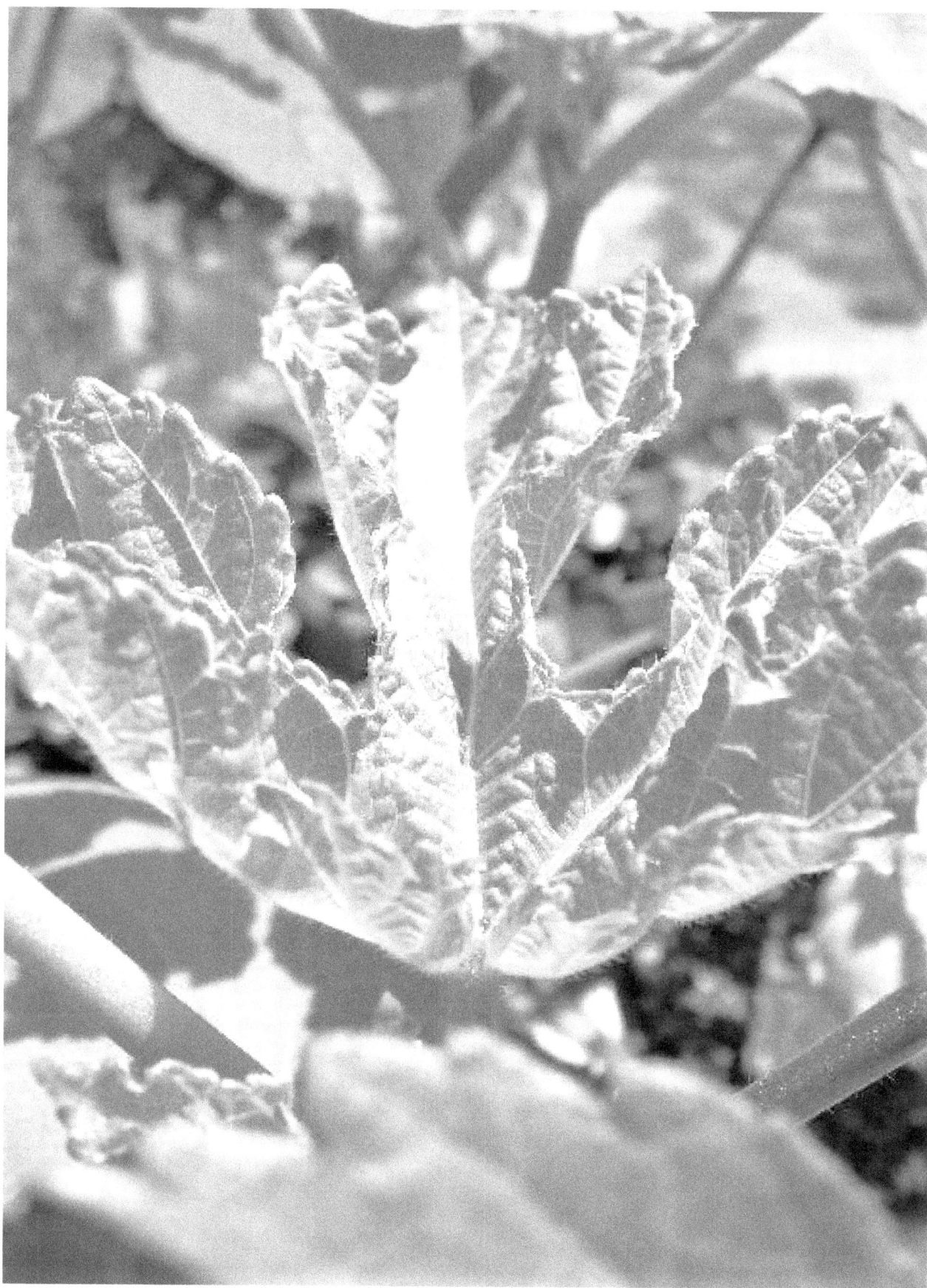

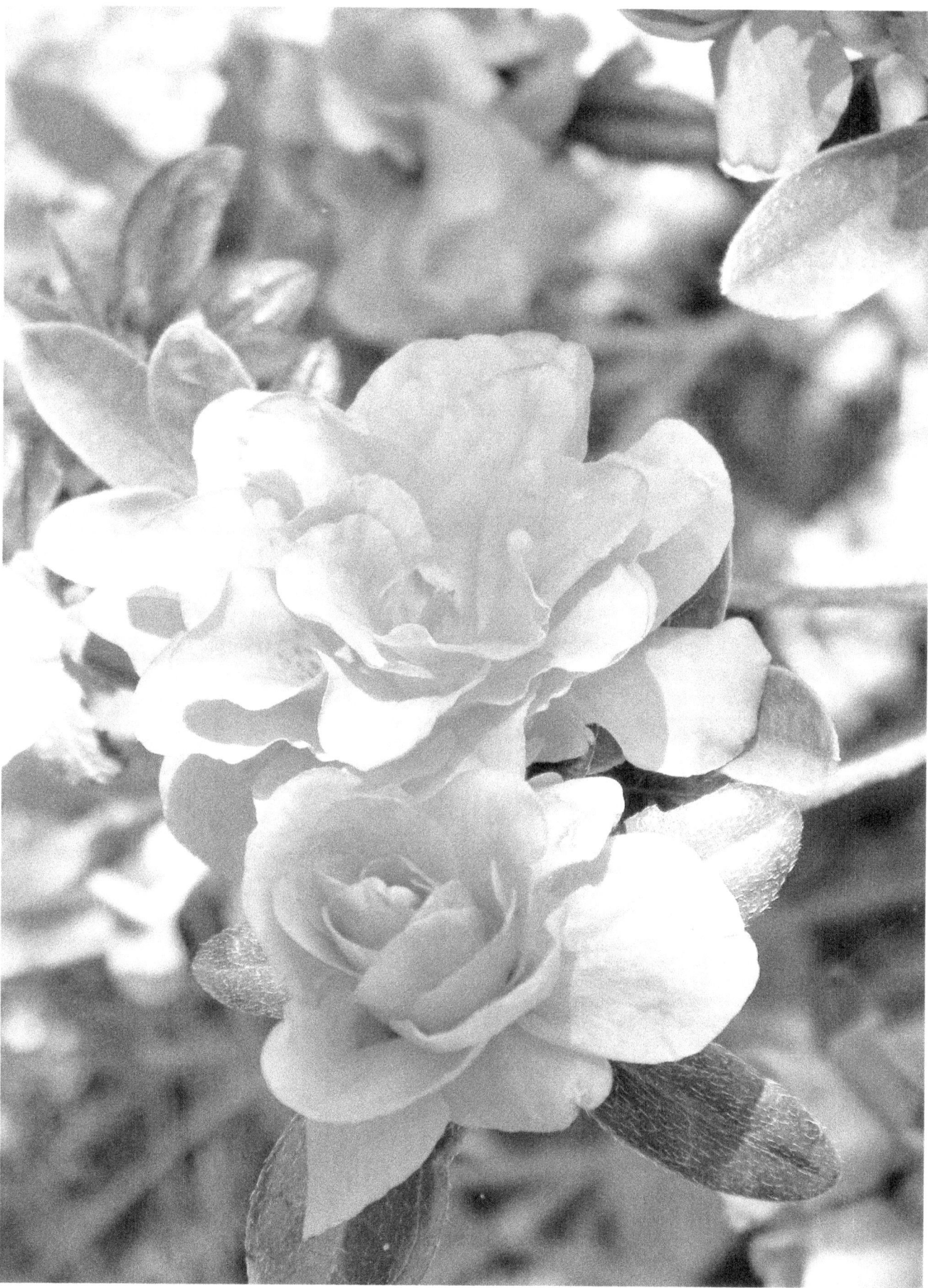

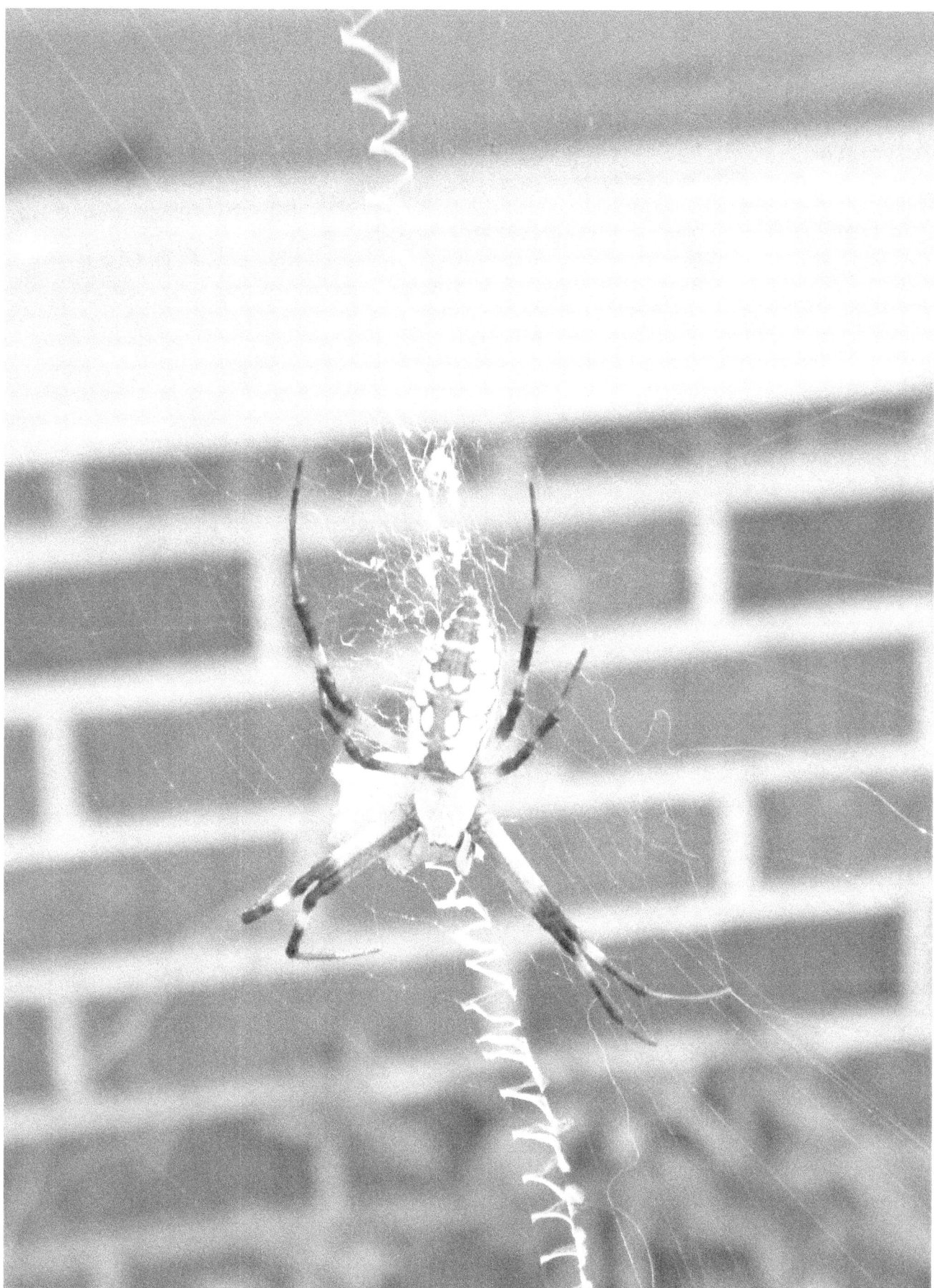

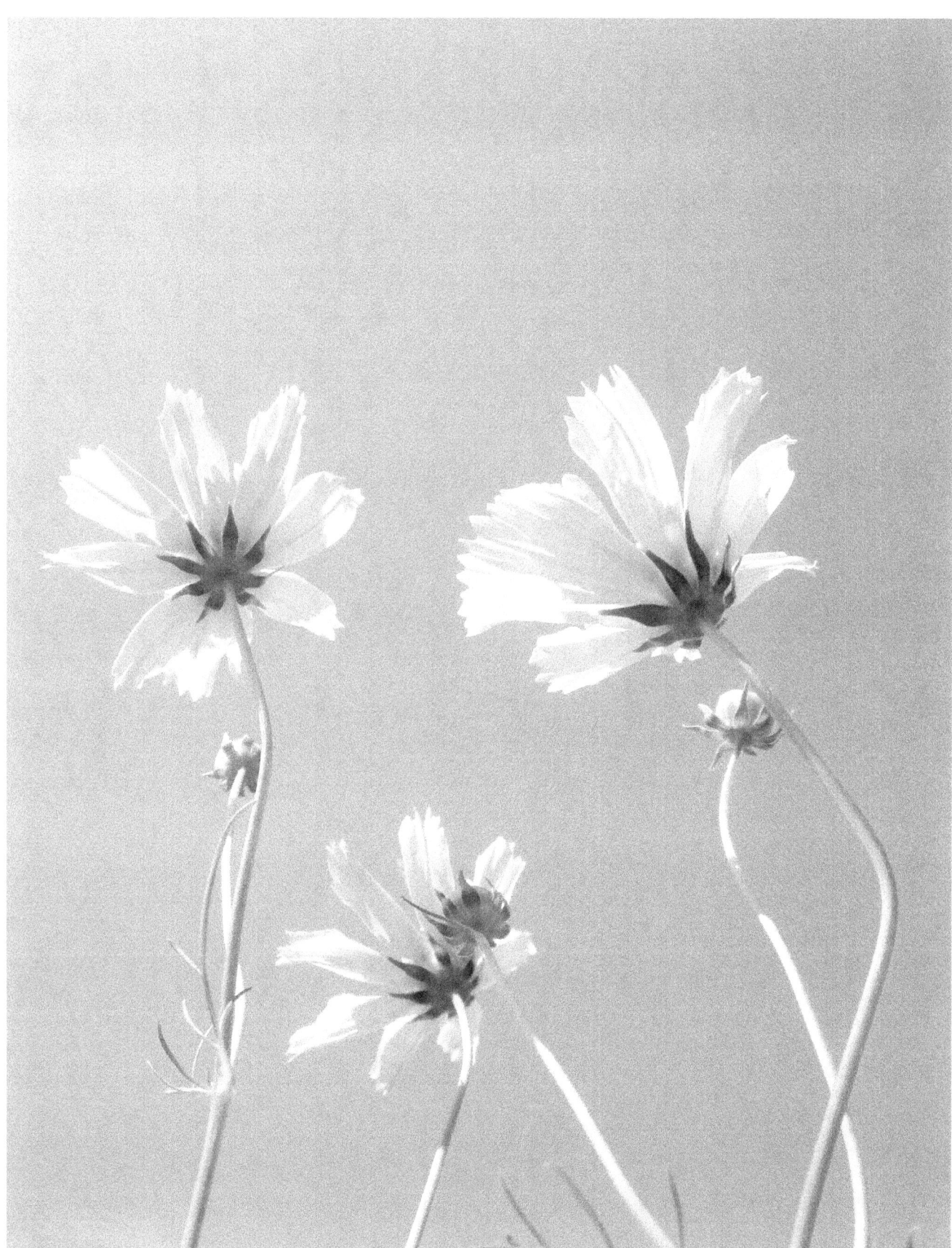

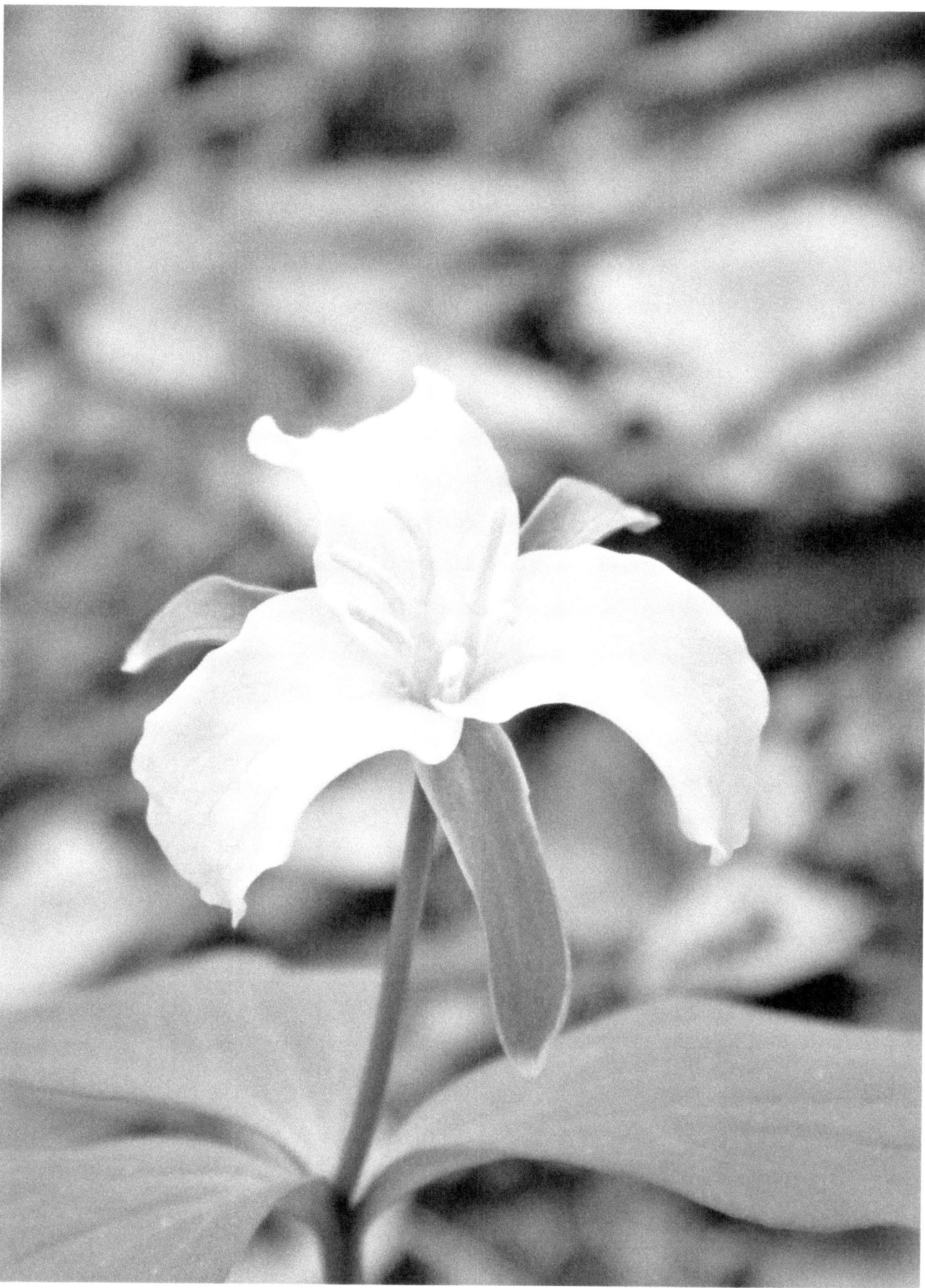

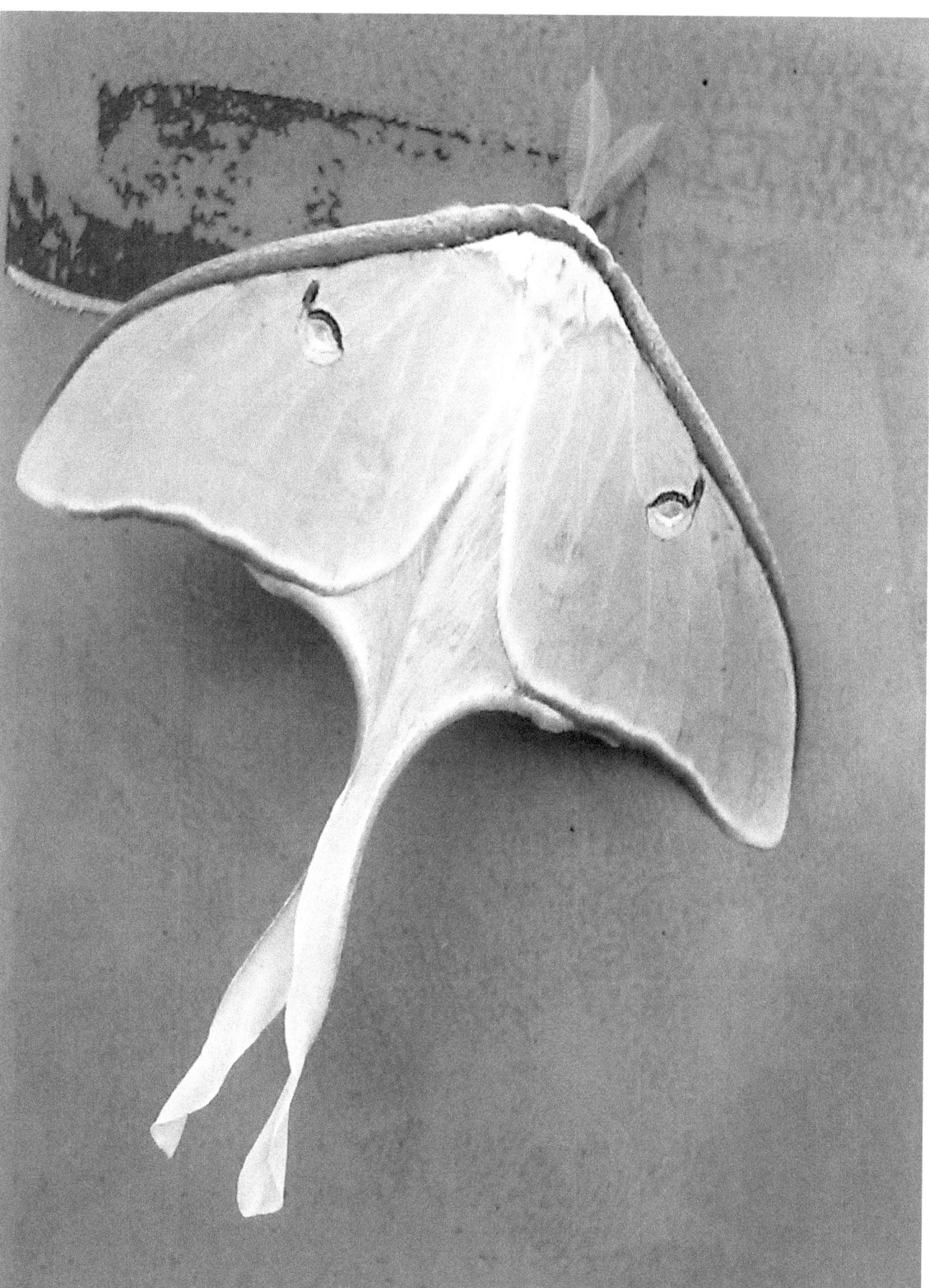

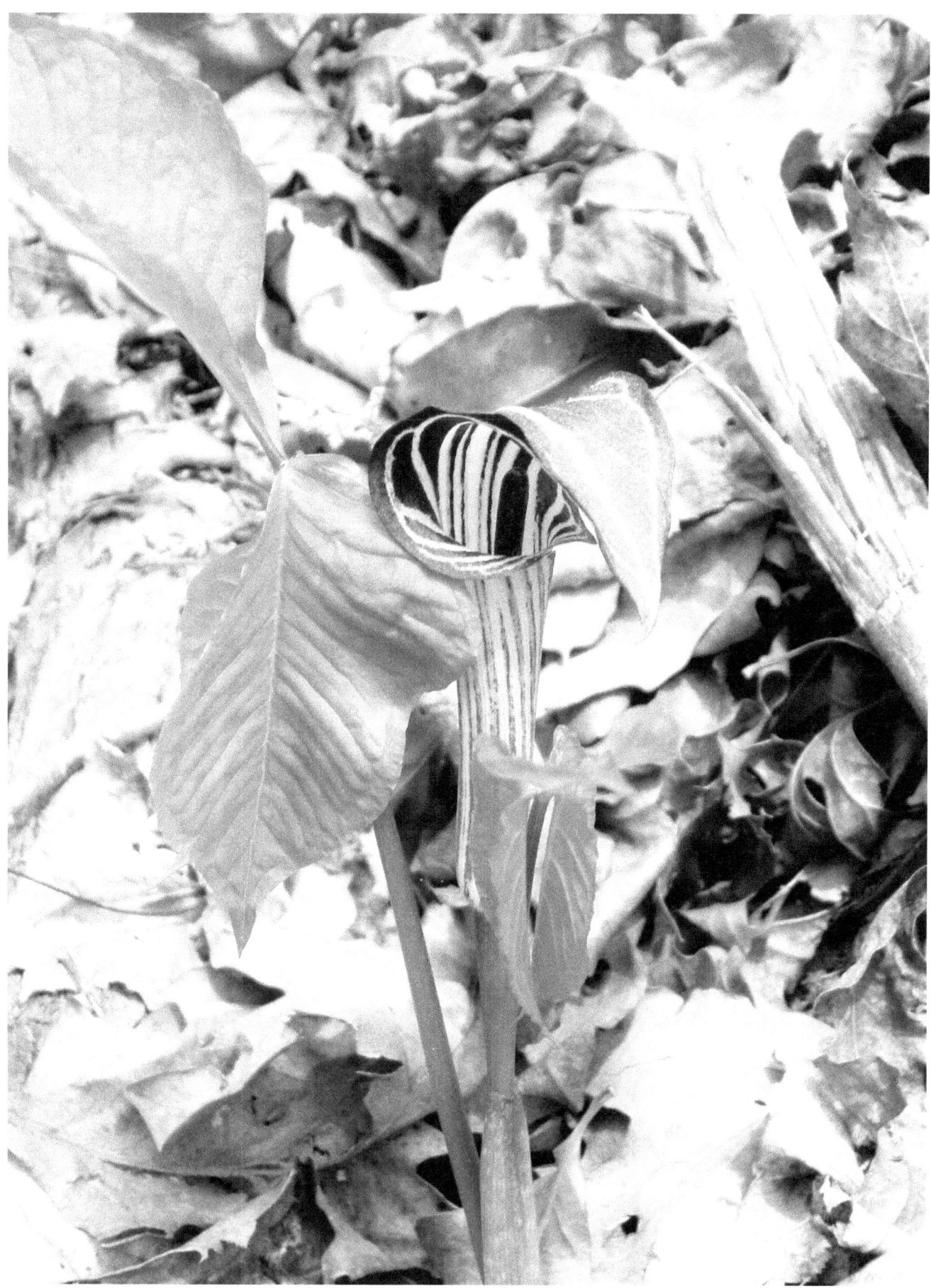

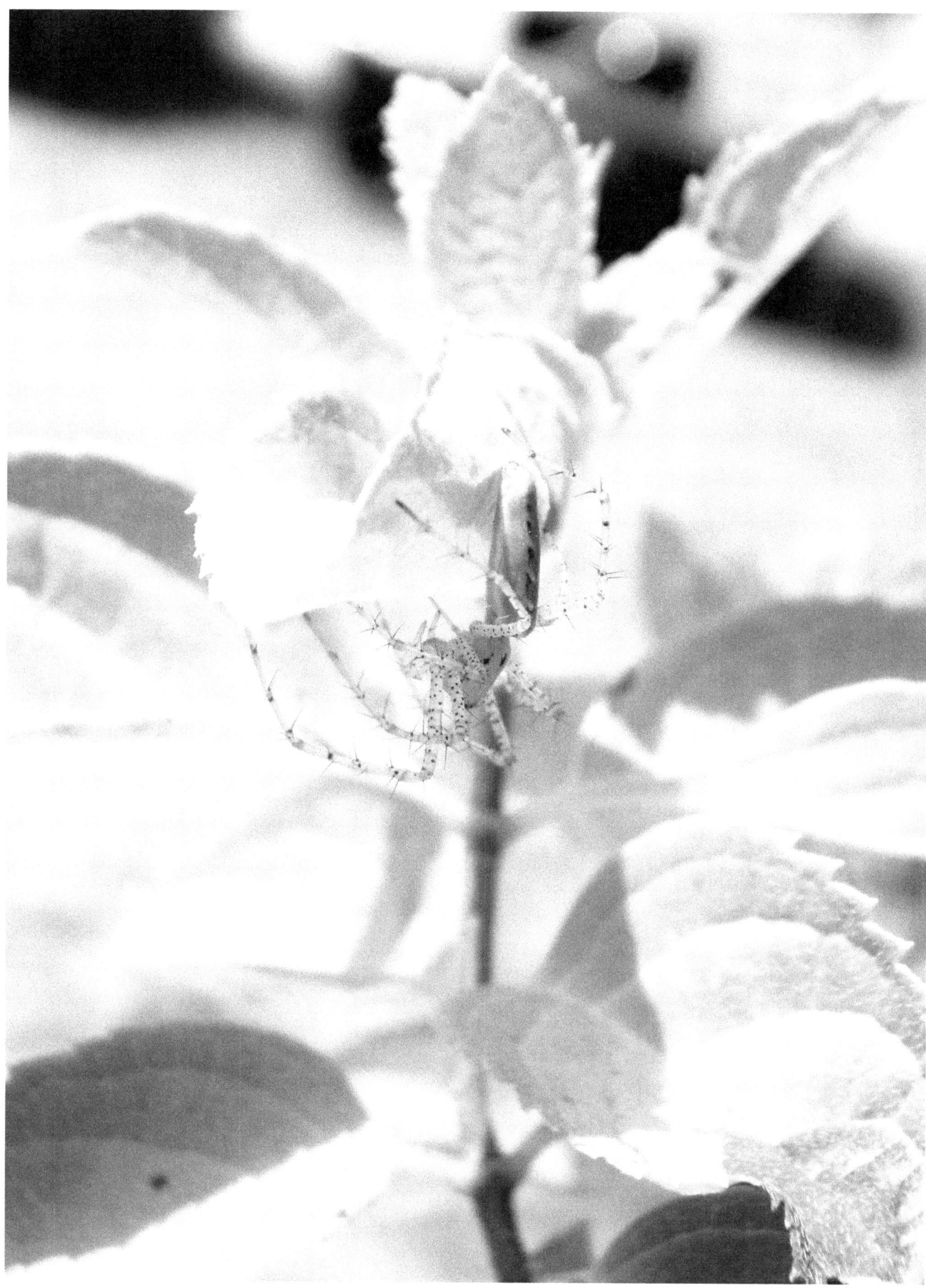

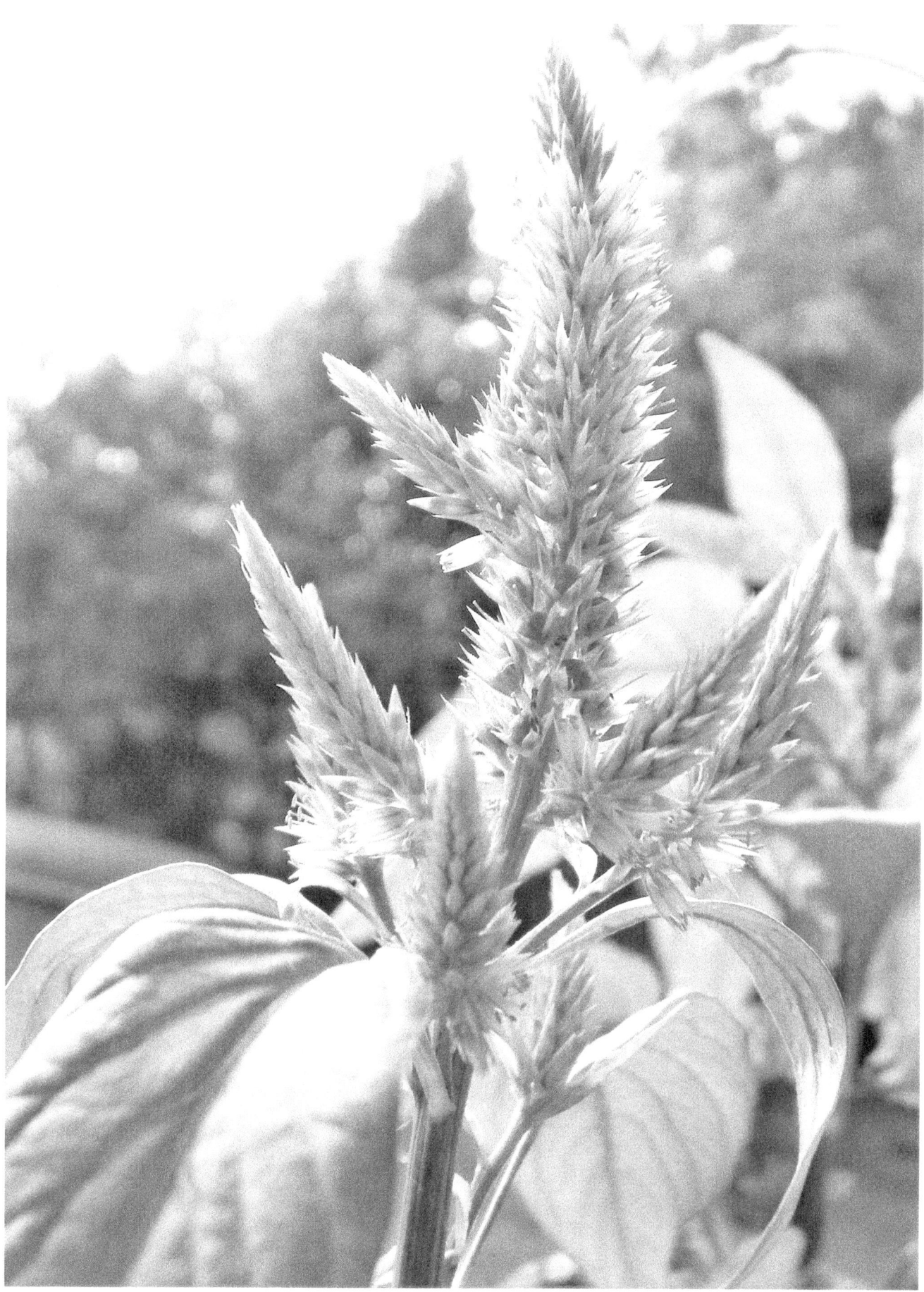

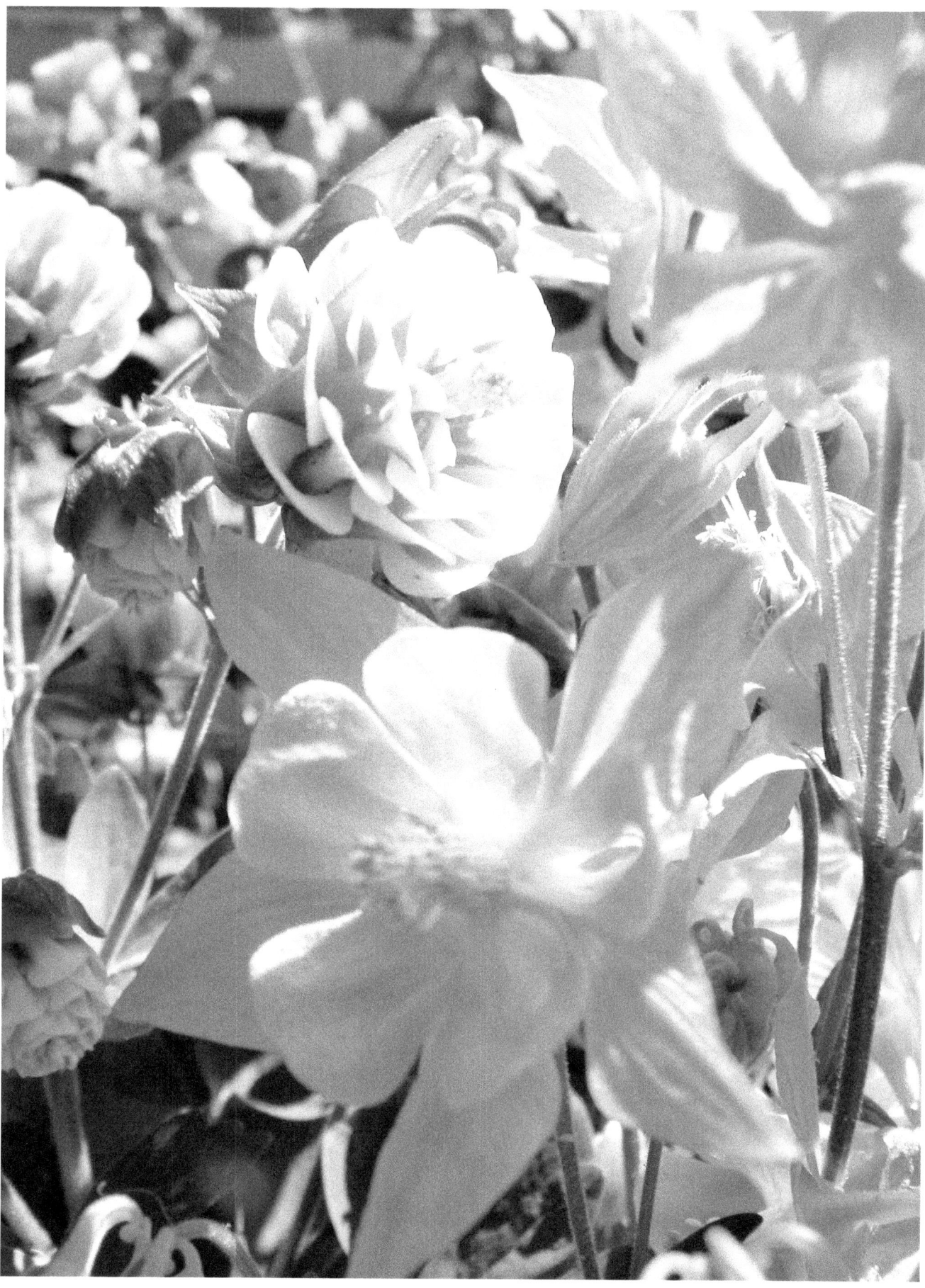

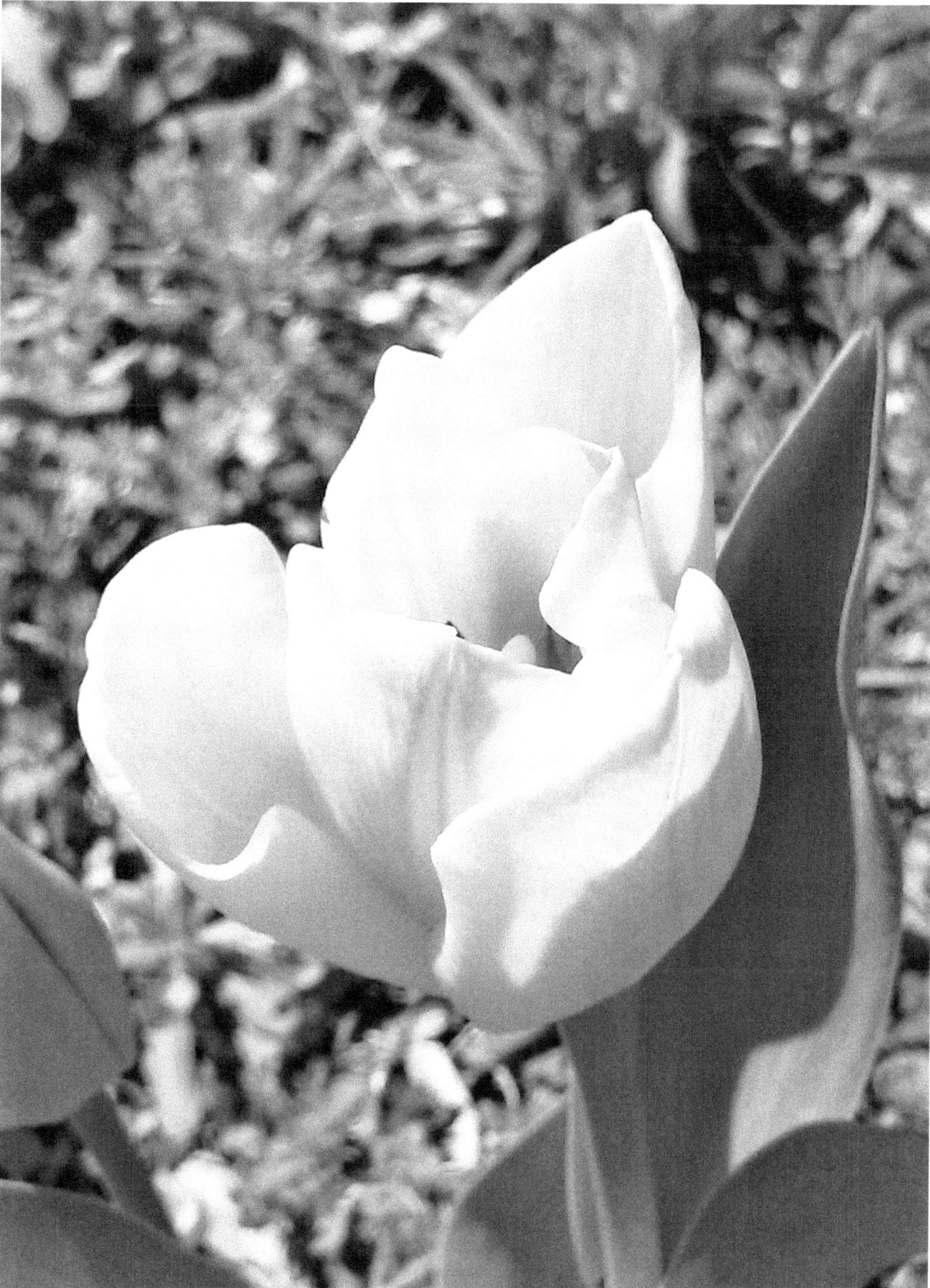

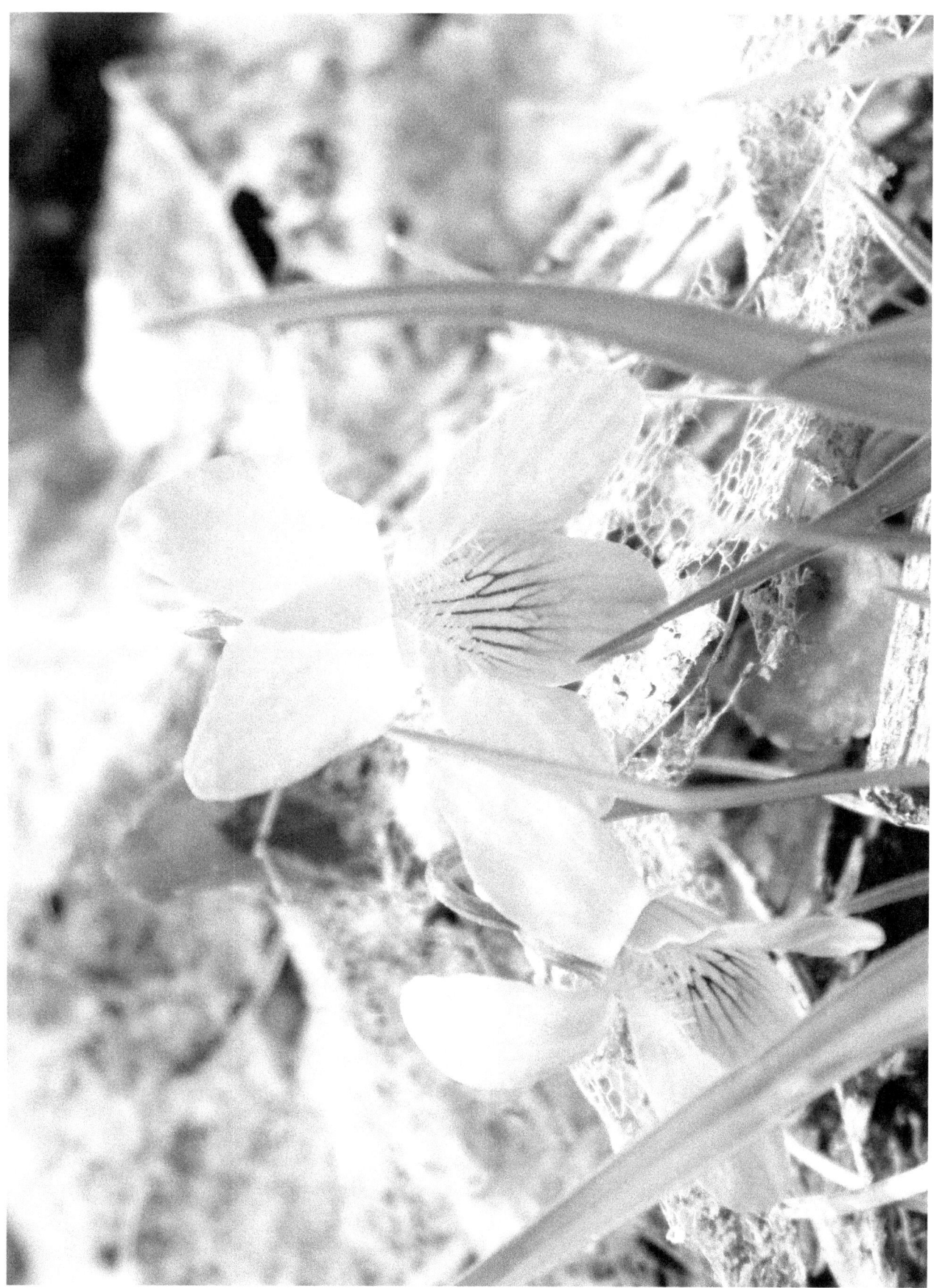

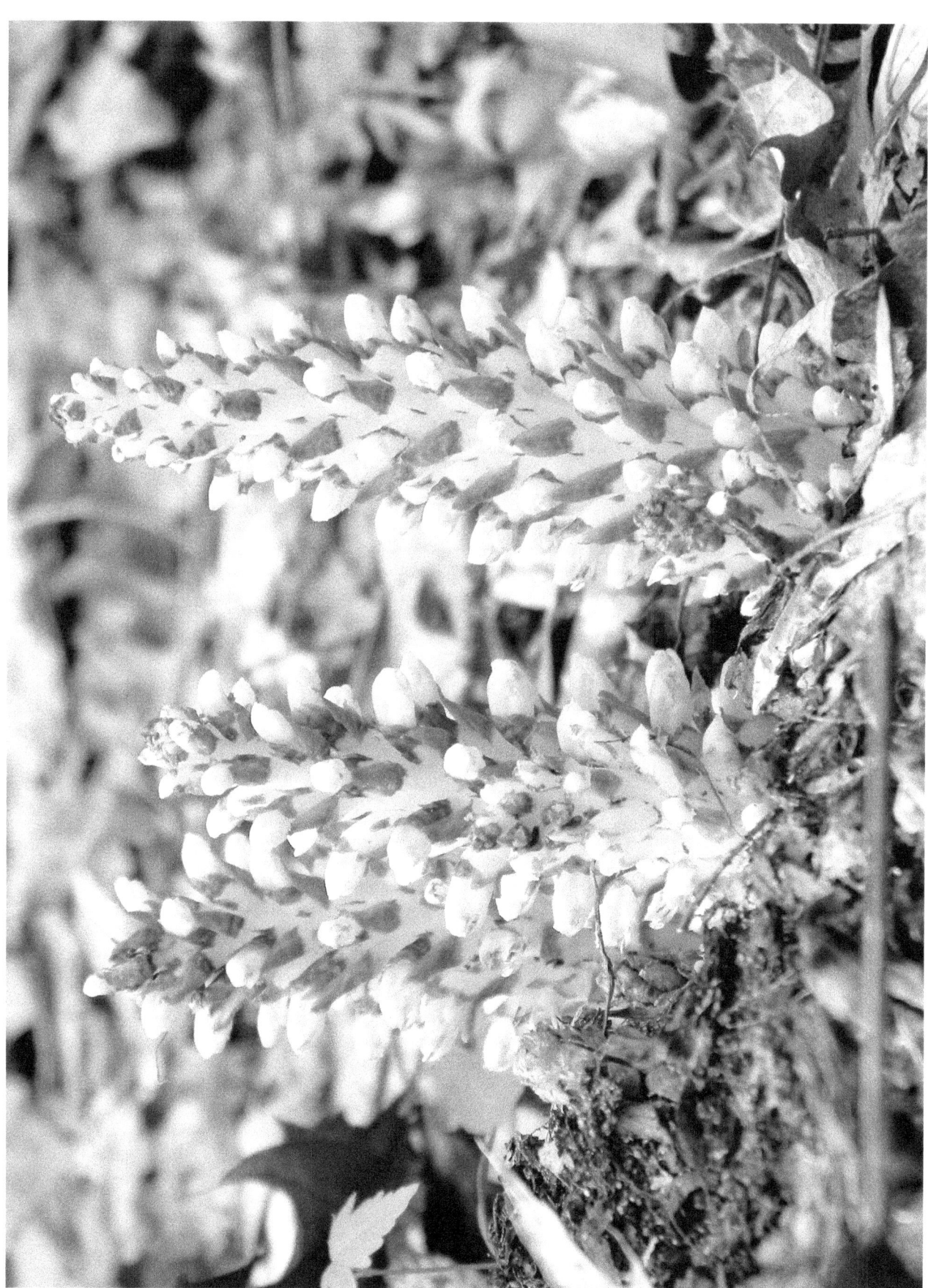

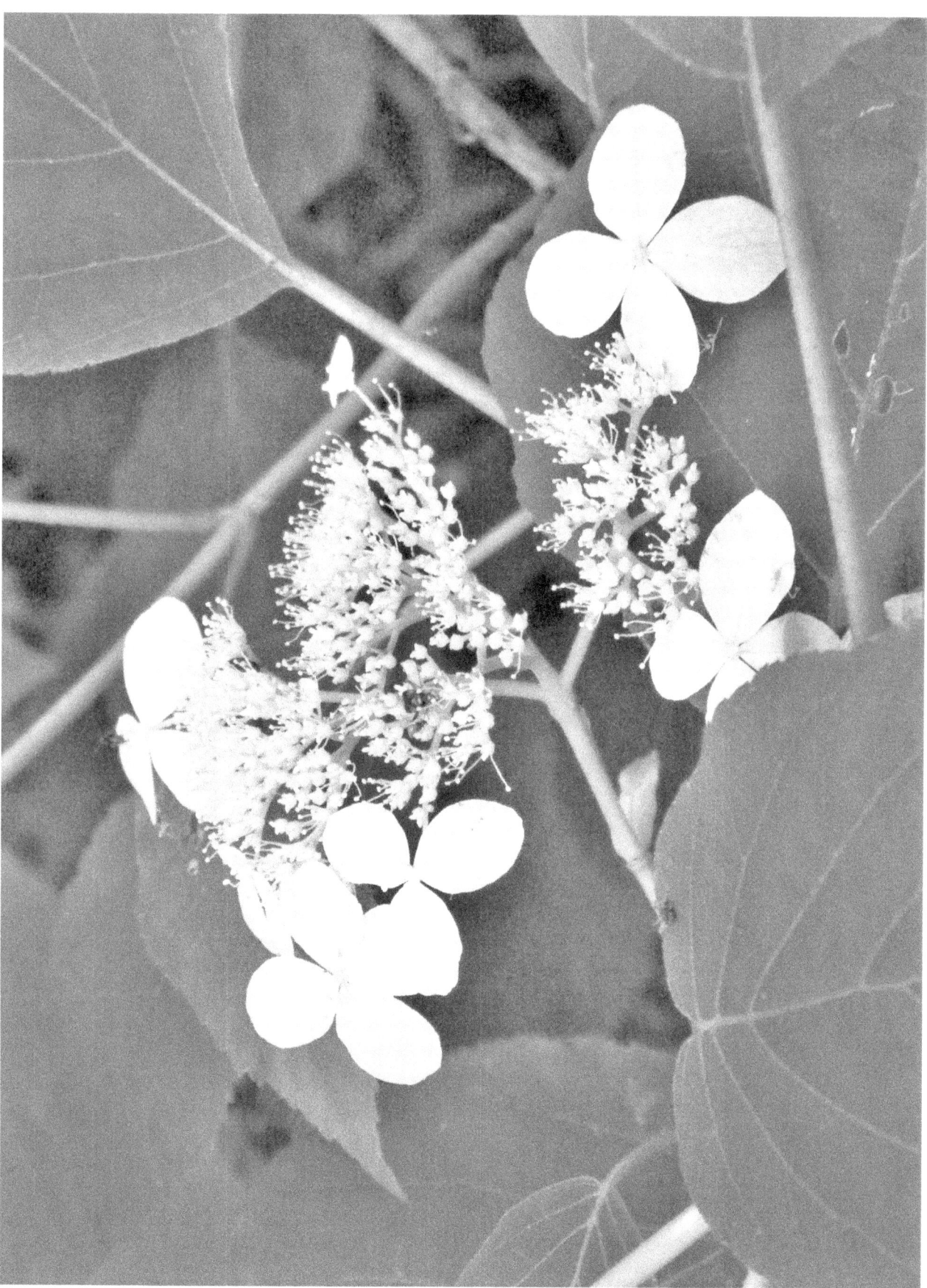

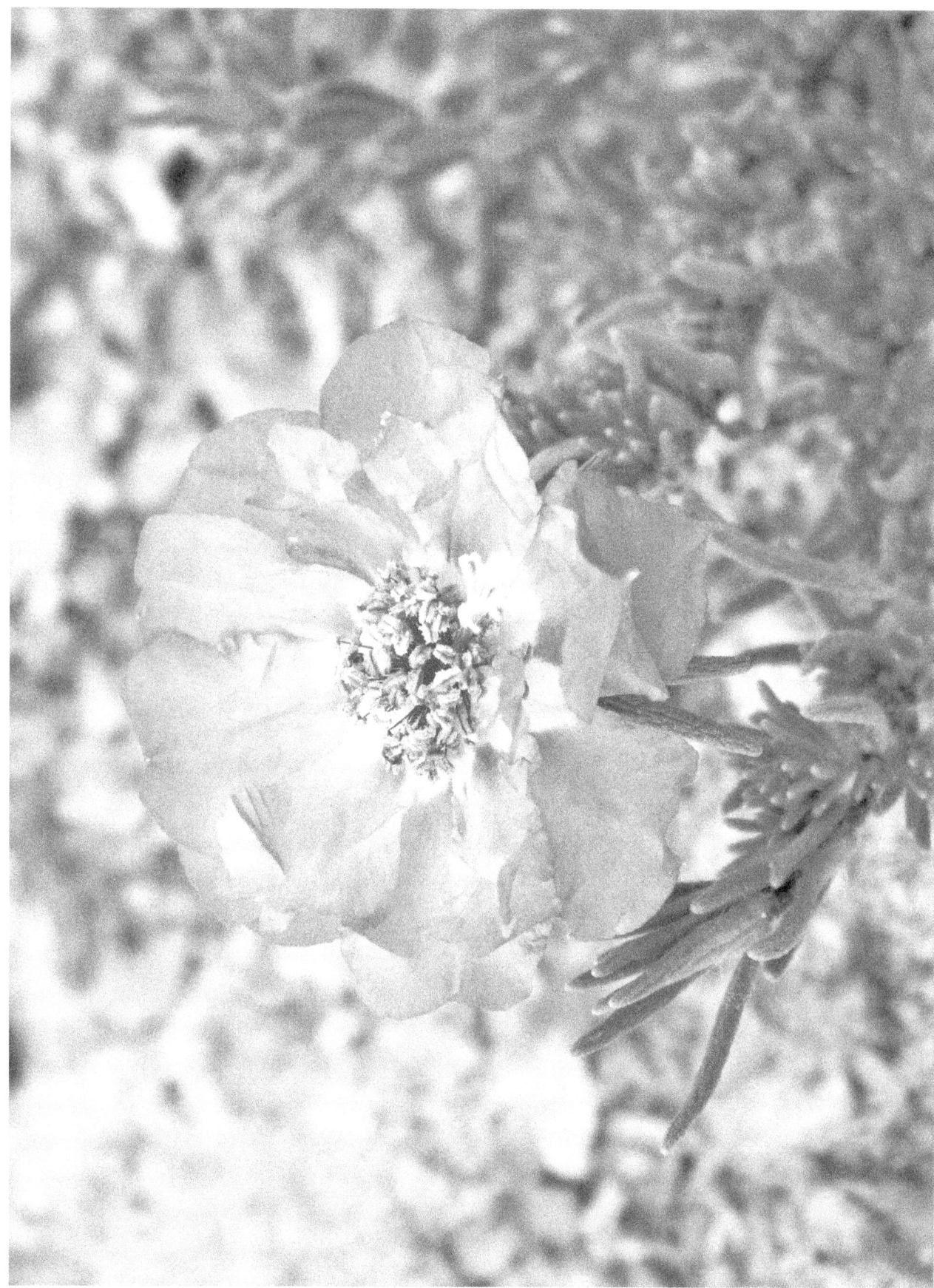

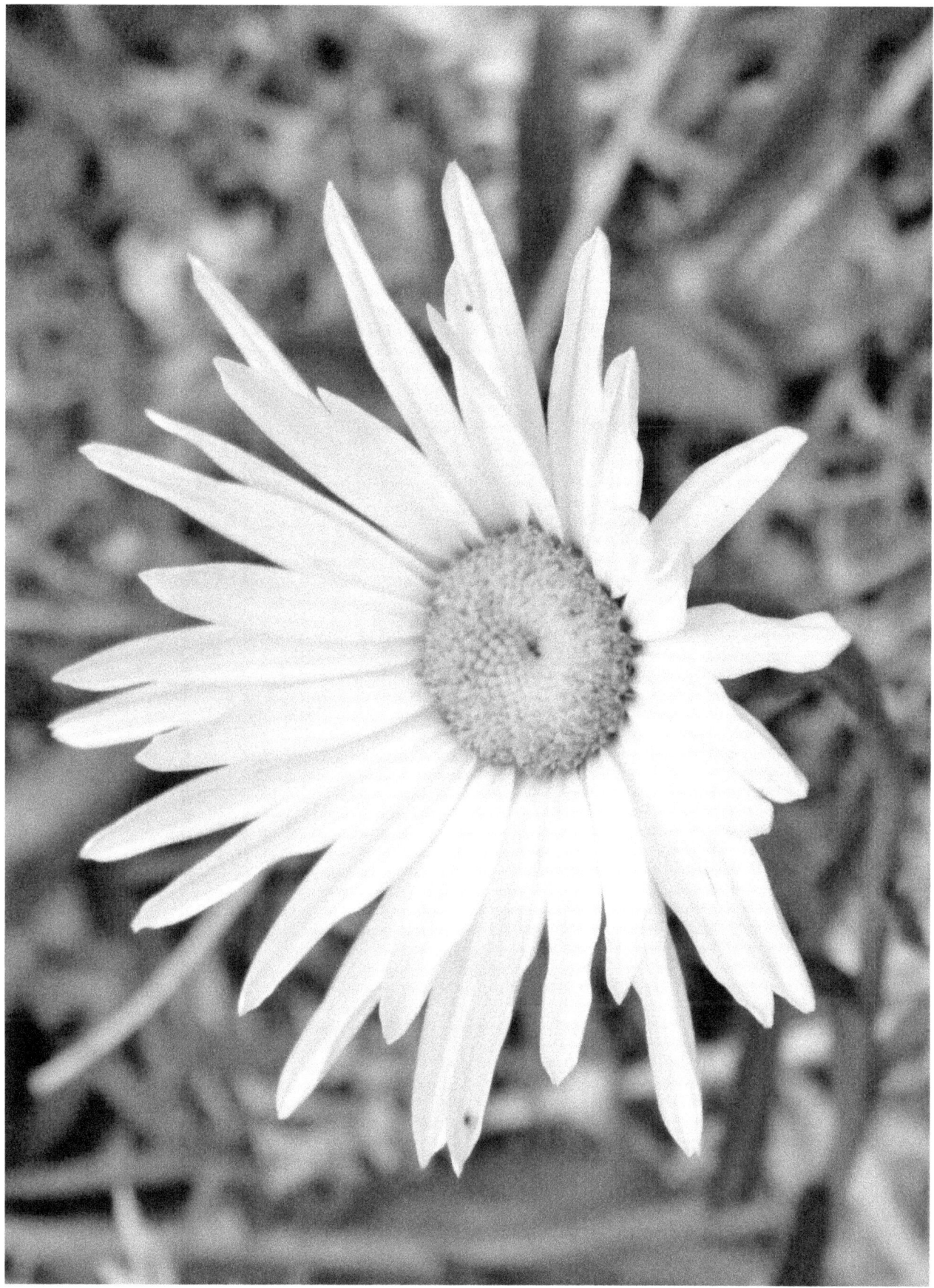

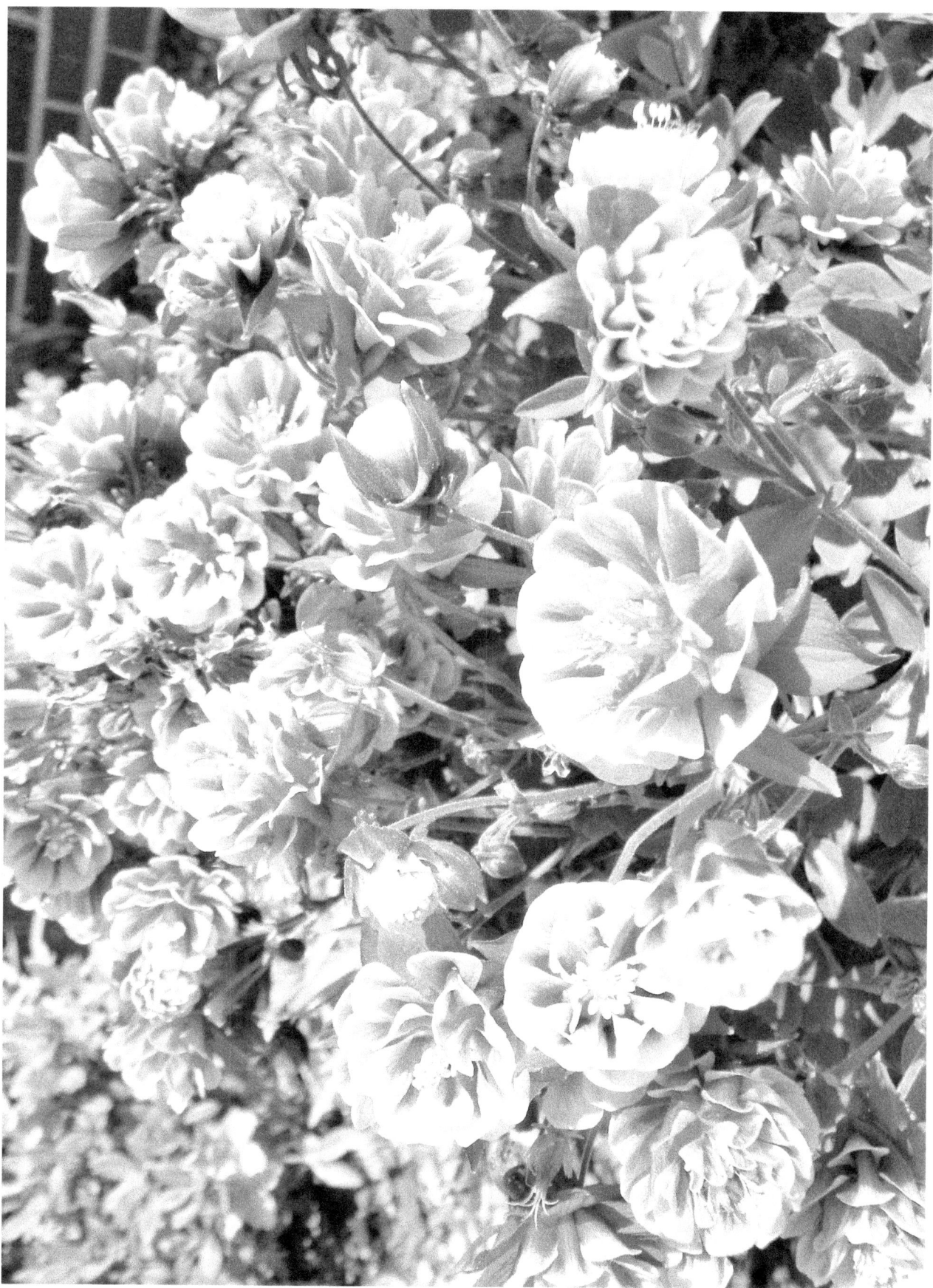

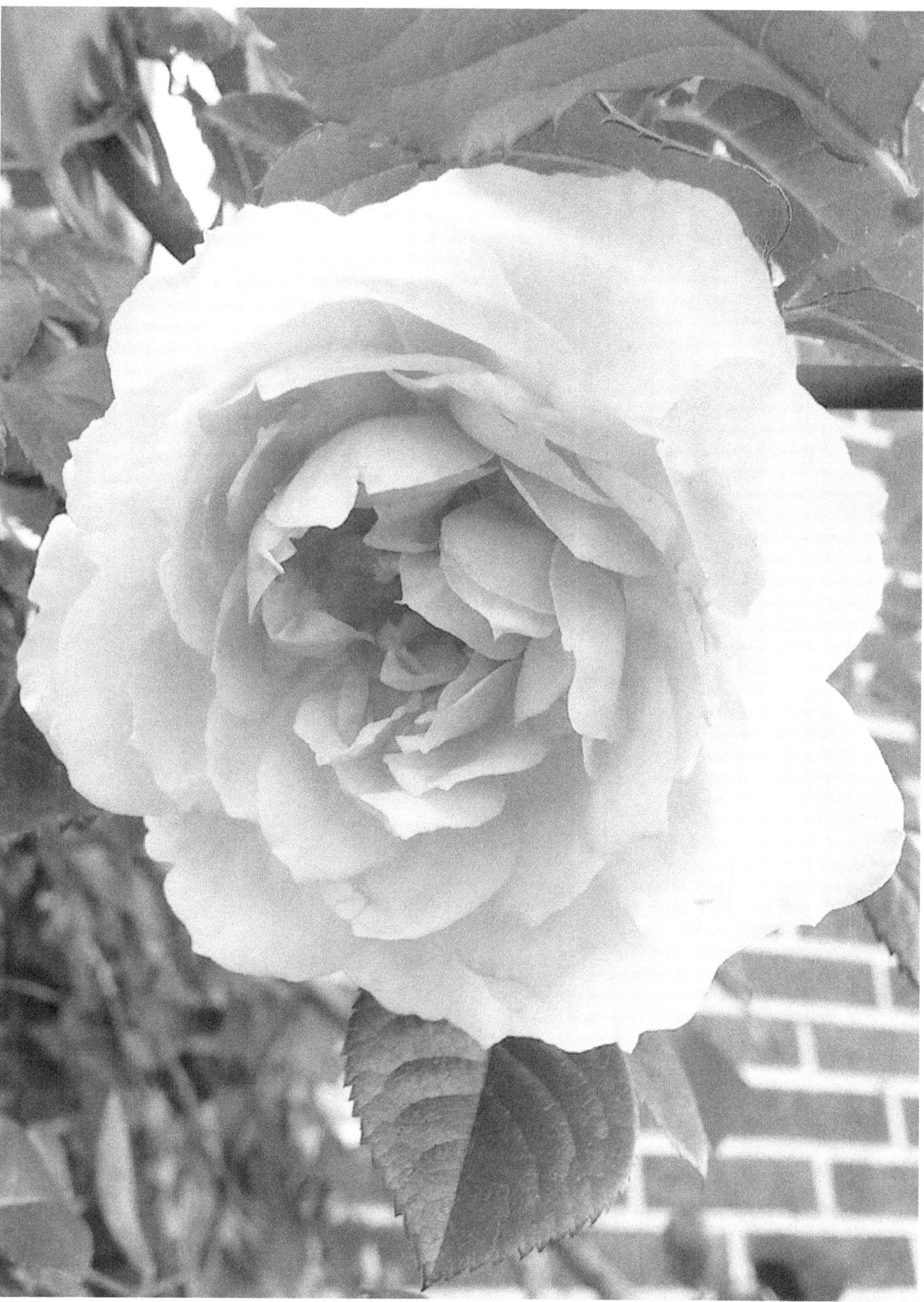

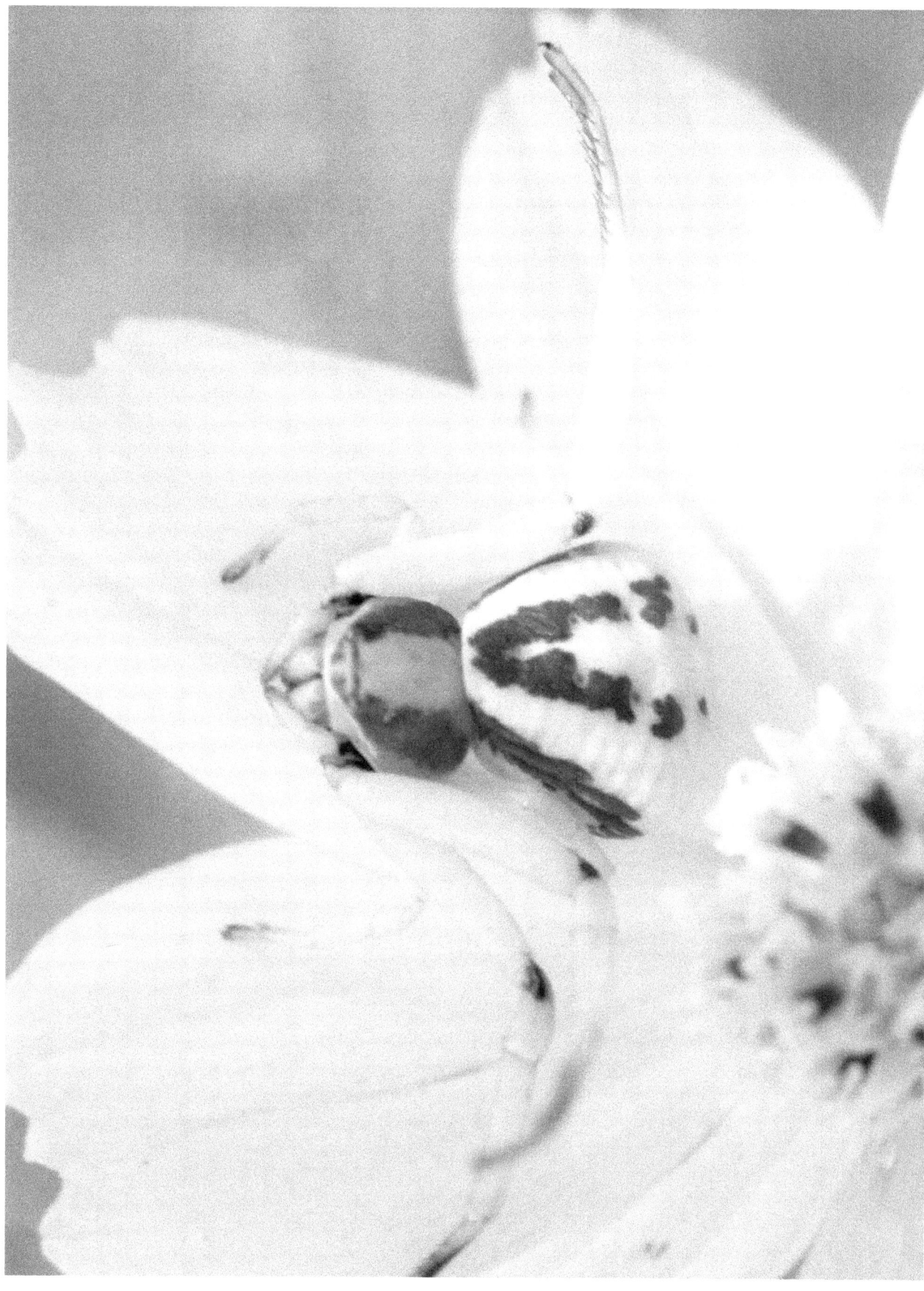

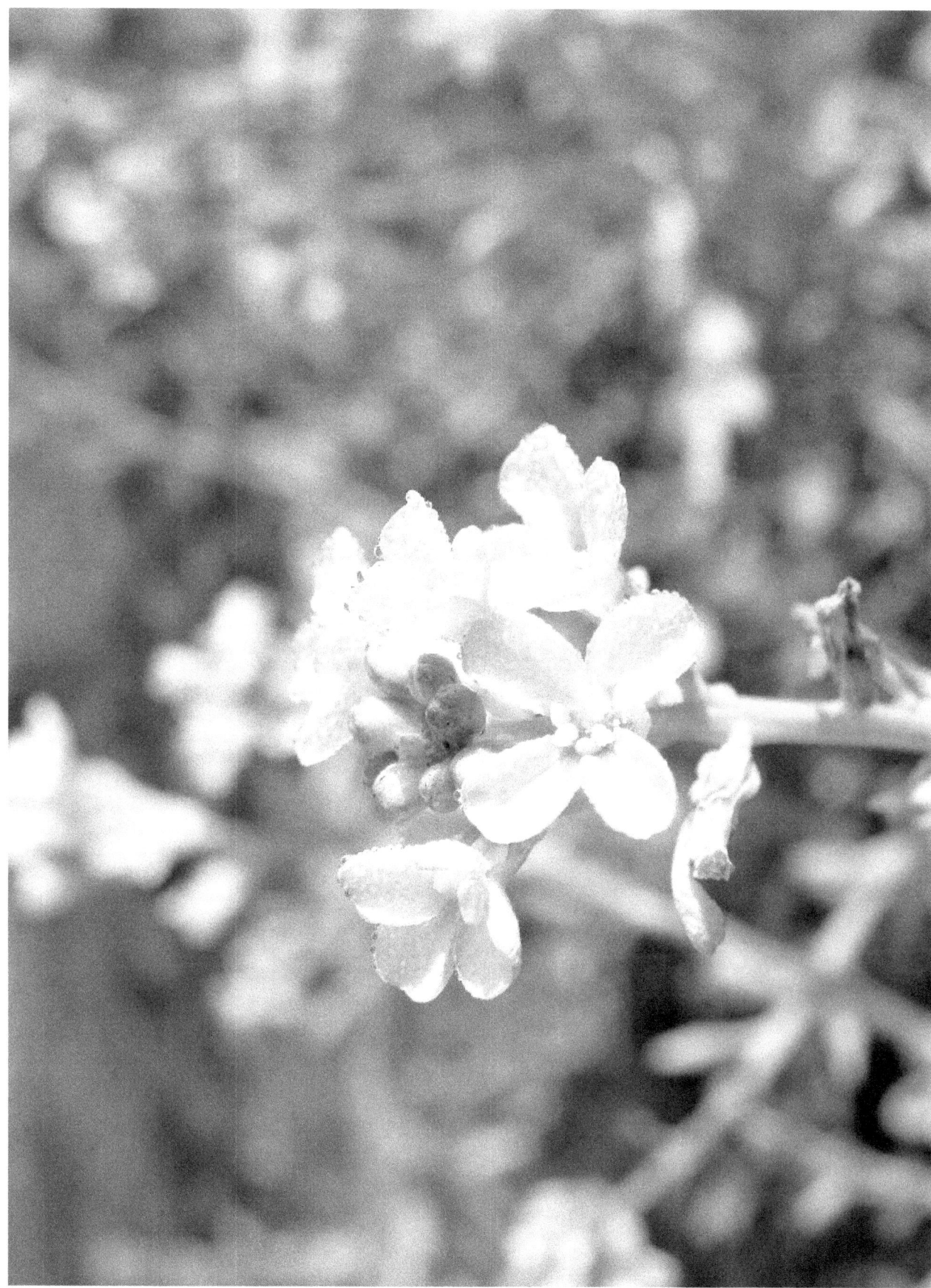

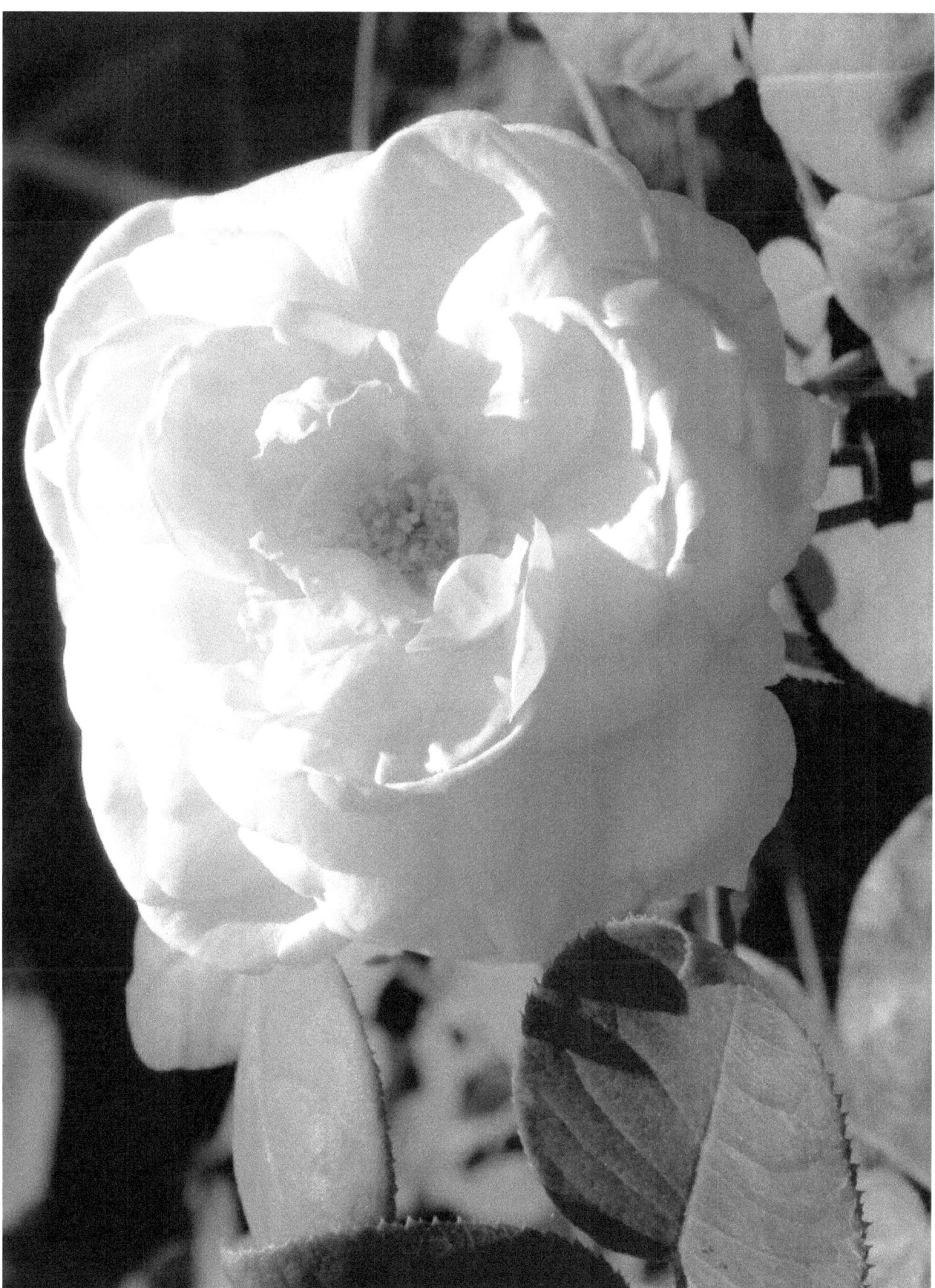

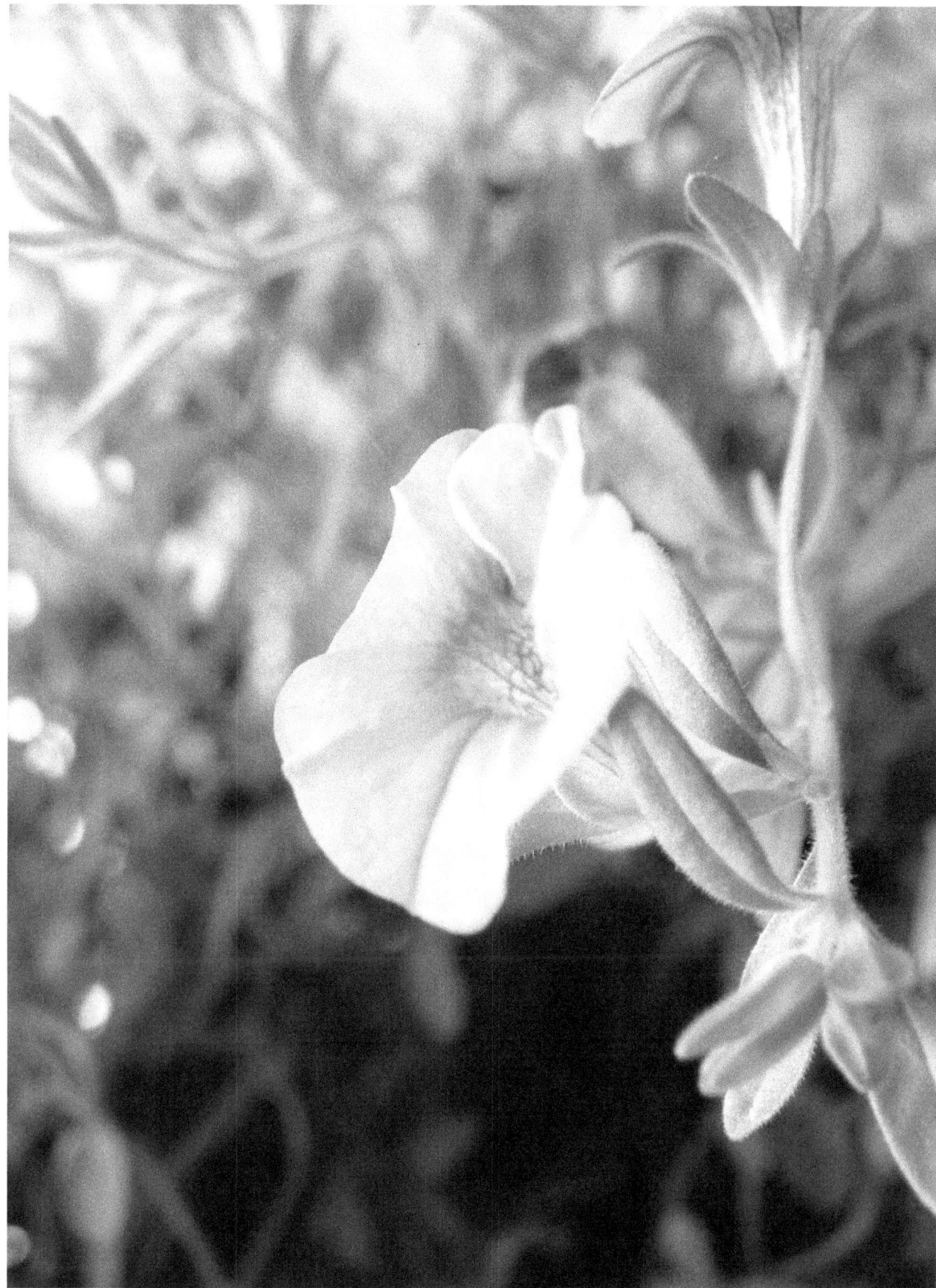

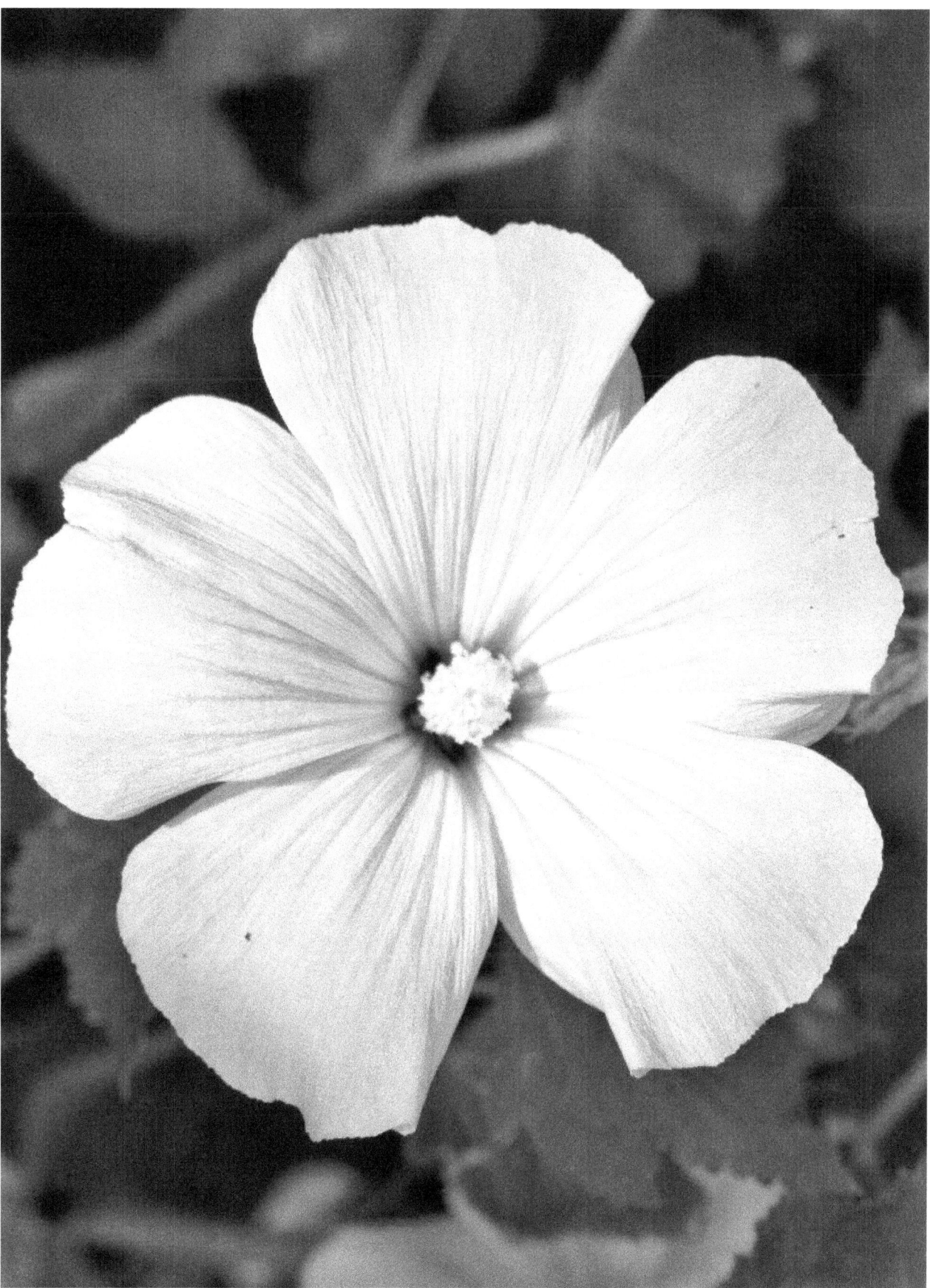

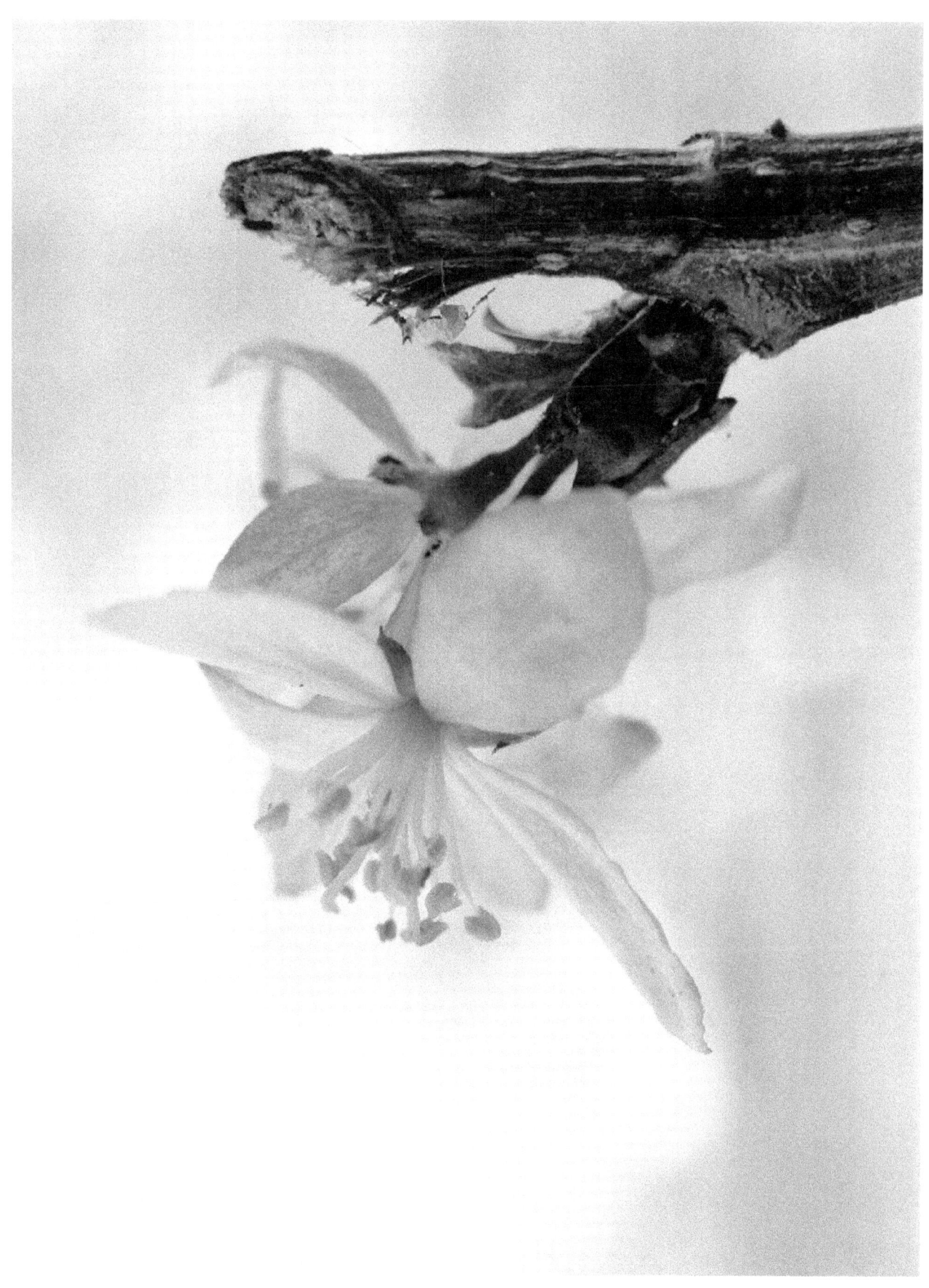

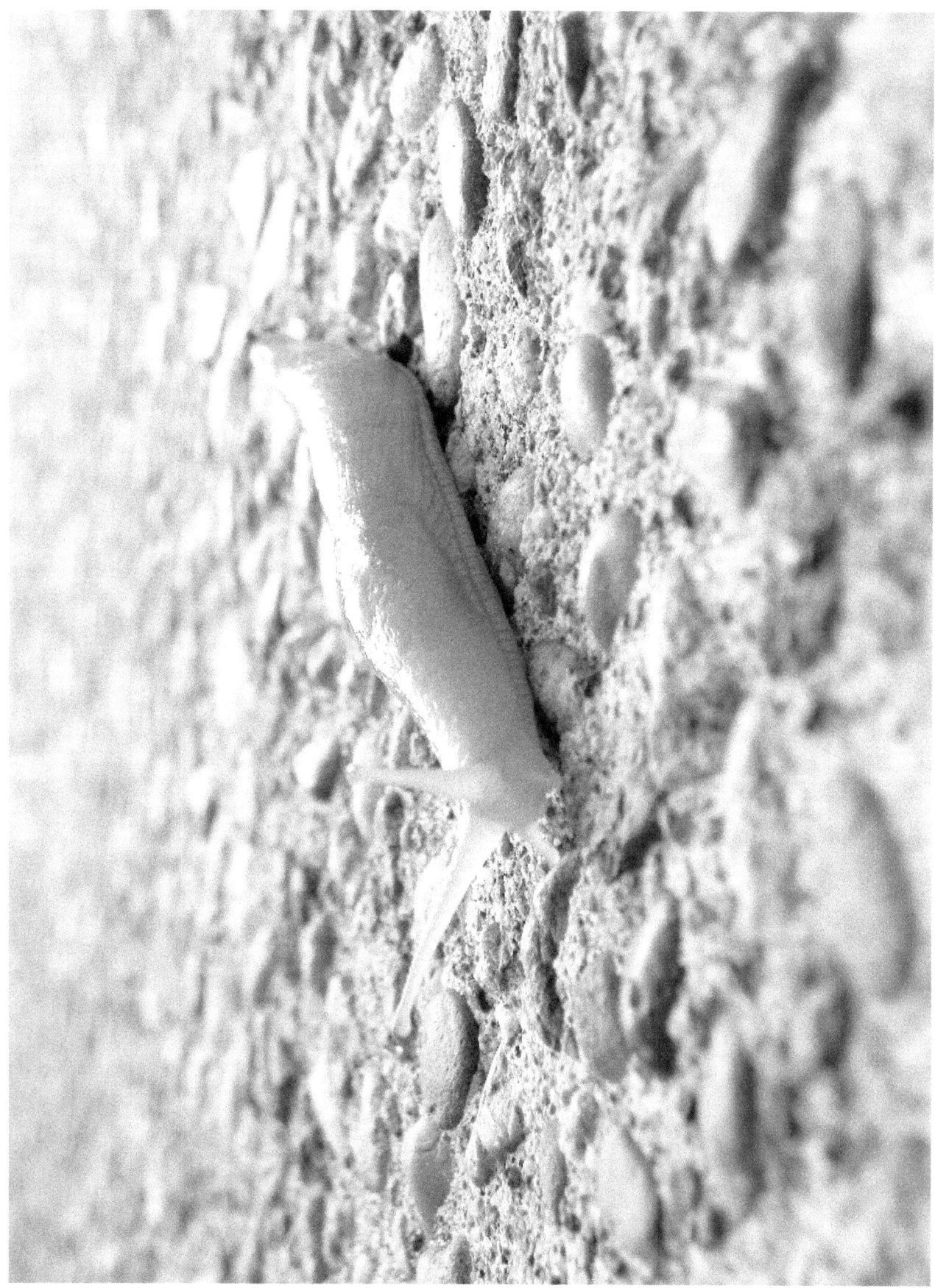

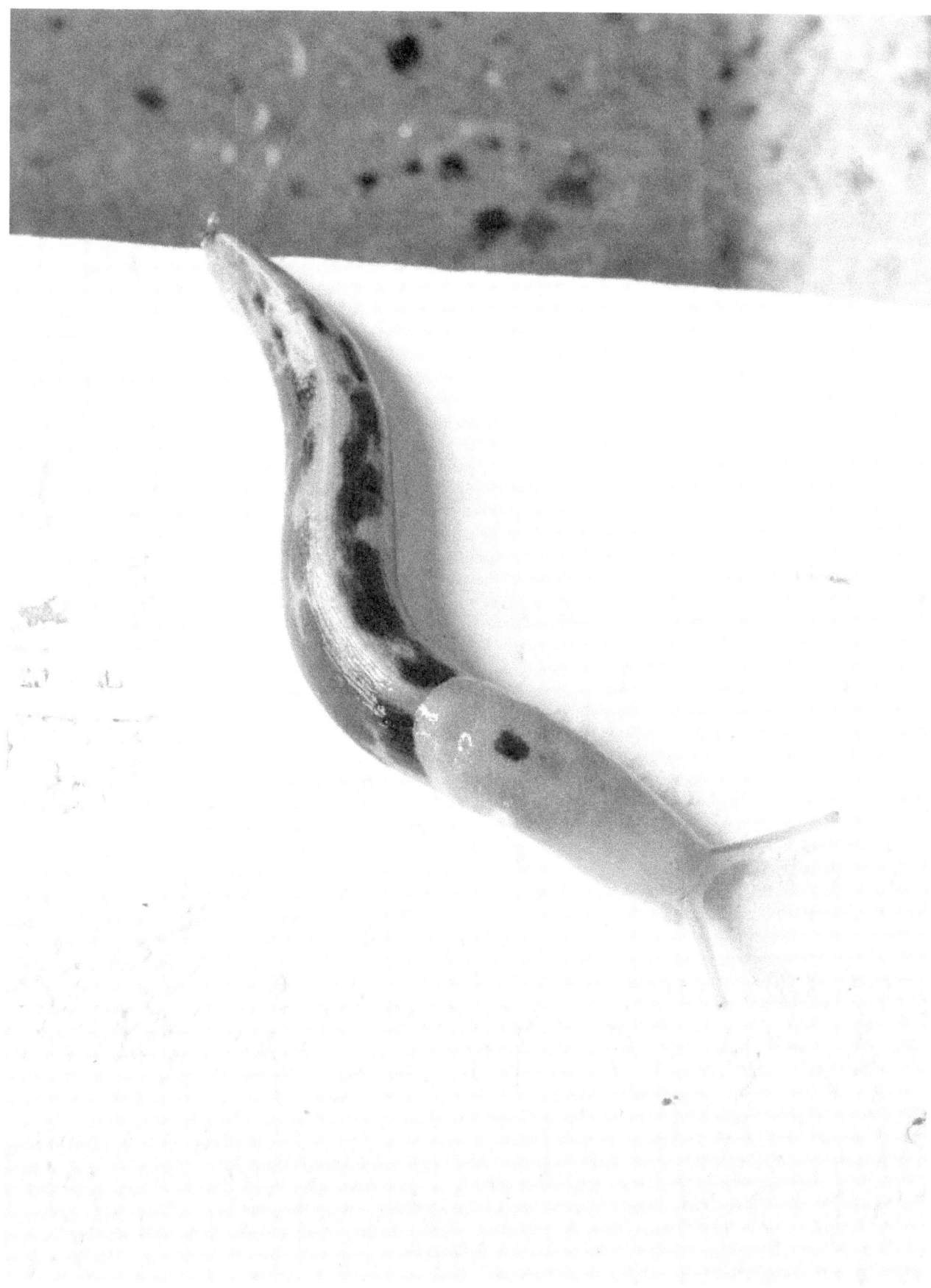

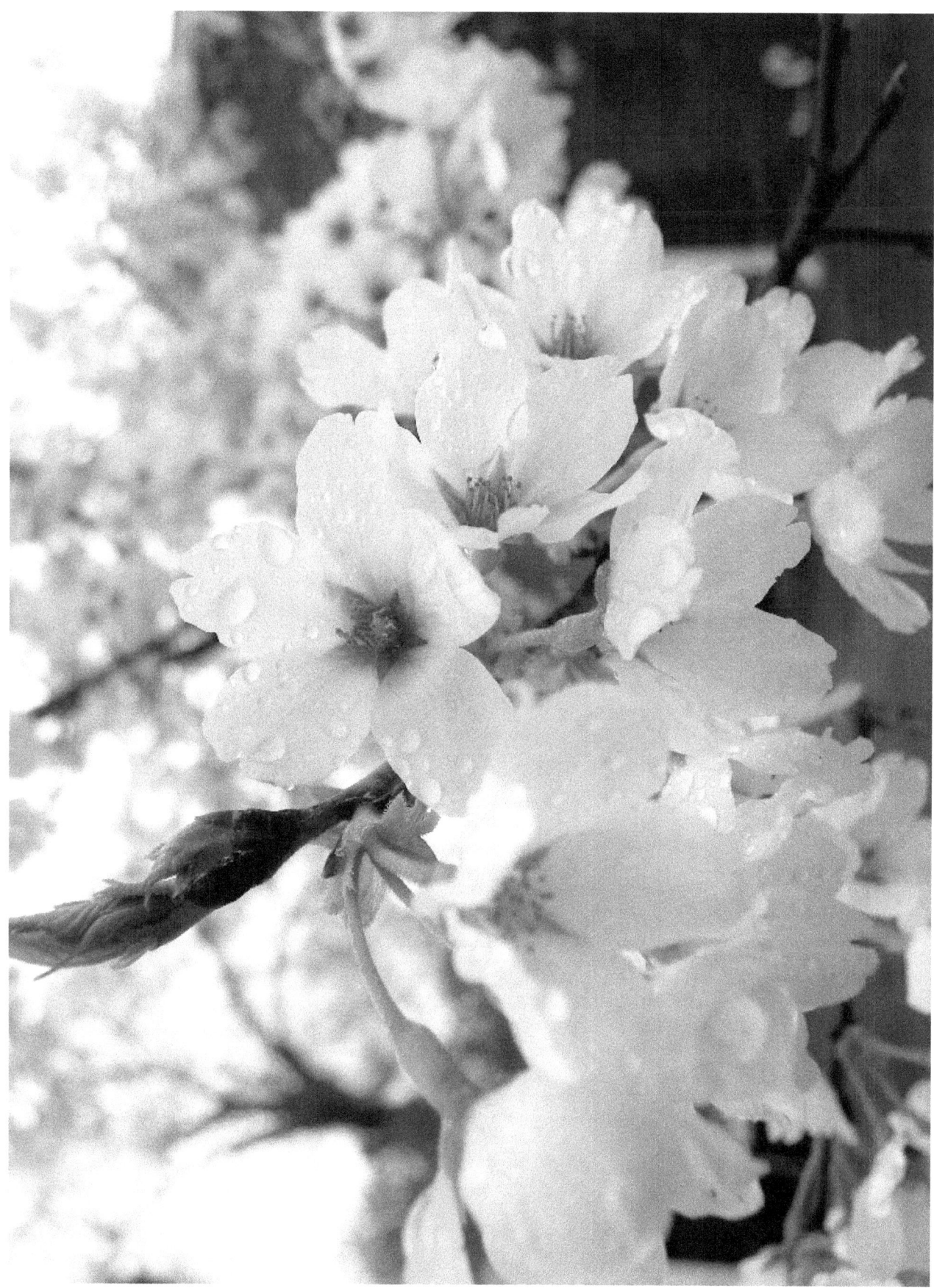

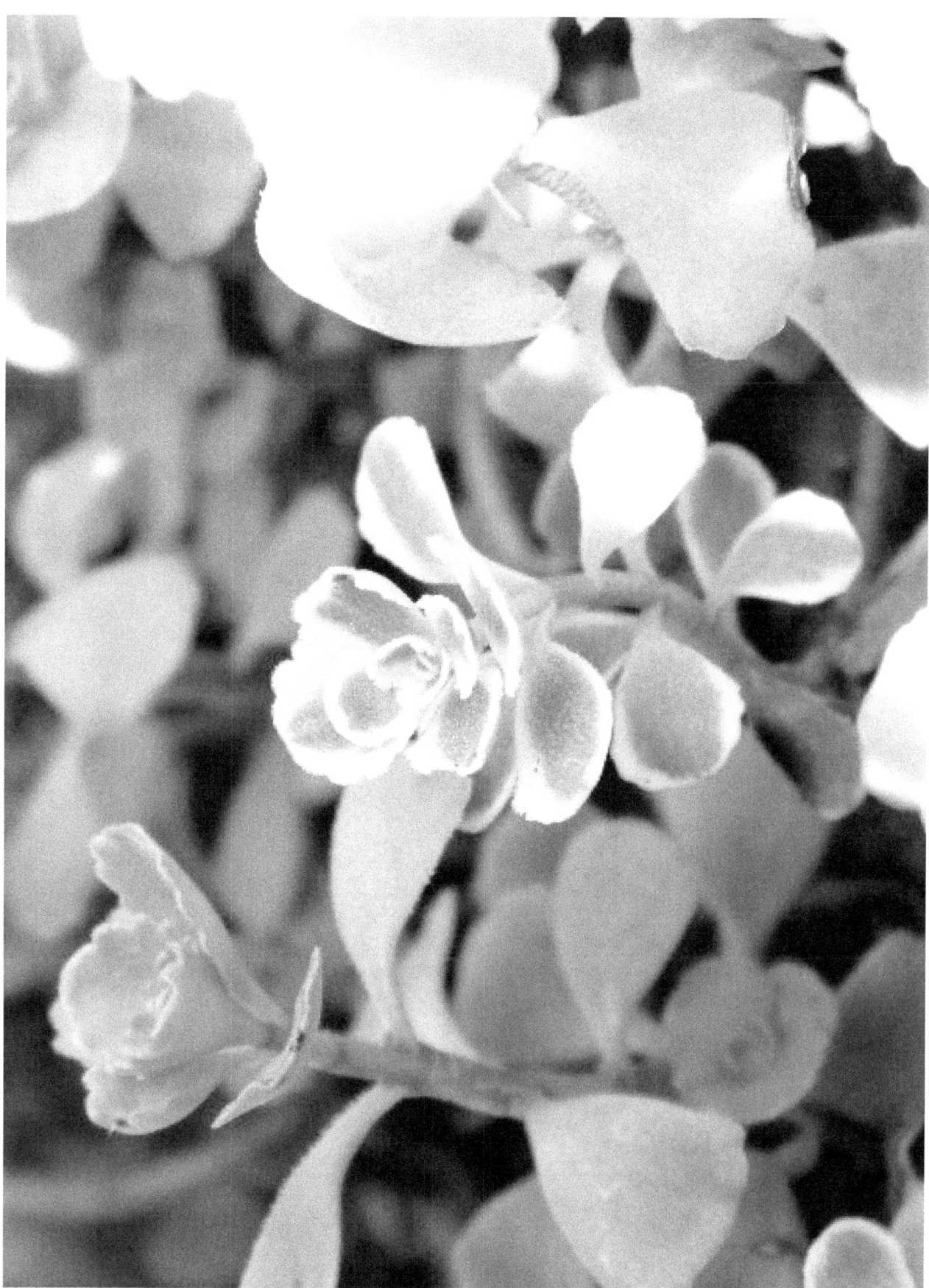

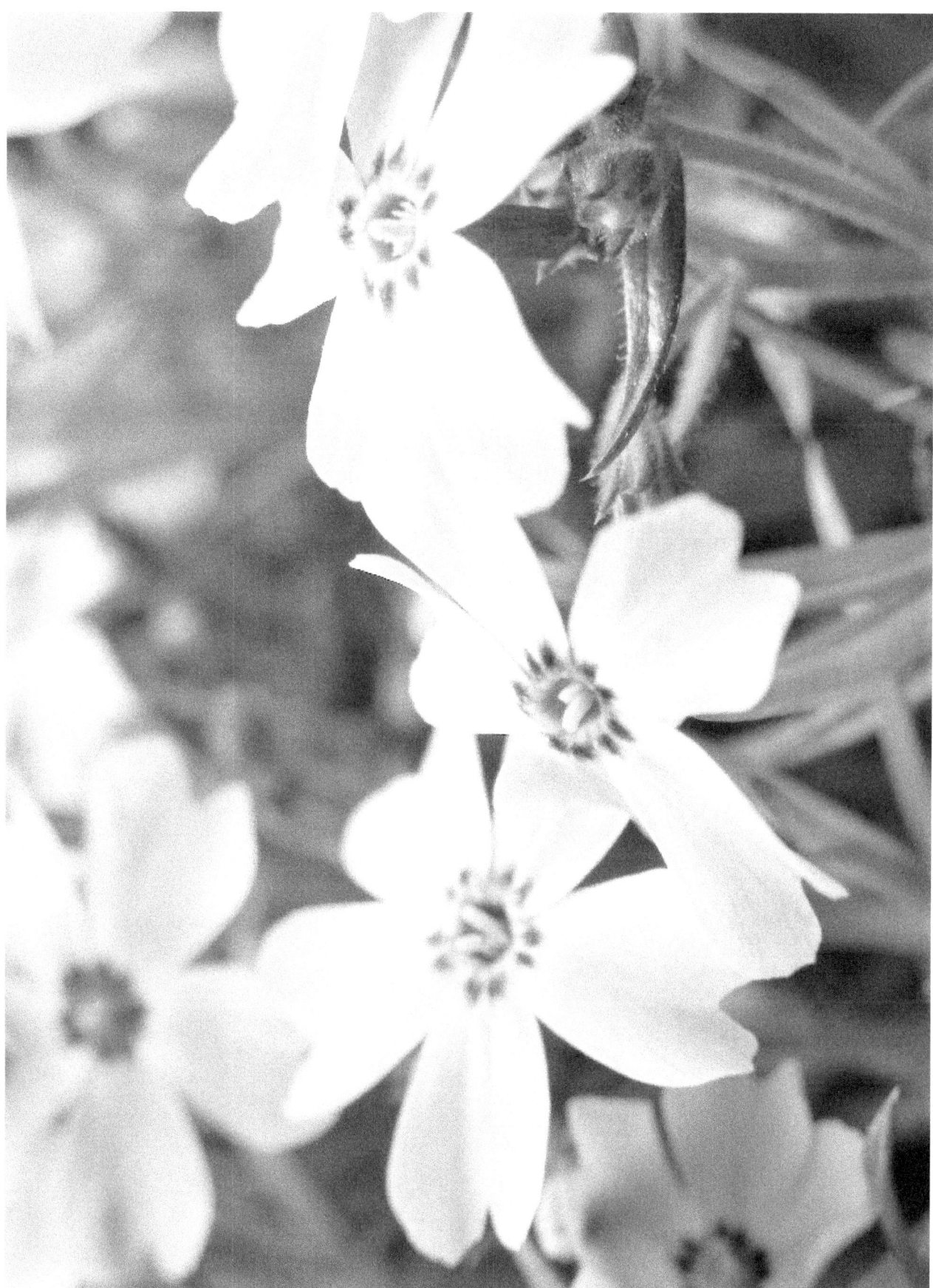

ABOUT THE AUTHOR

Erika grew up with sand and sun in her hair in Narragansett, RI. Ever the adventurer and all around tiny animal finder, her interest in the small details and the humble parts of nature took hold.

She was set up on a blind date at 17-years-old where she found her husband. They raised three children in Groton, CT where their home was surrounded with woods and streams which helped nurture their kids' interest in nature.

Erika's background includes working as a CNA, MA(AAMA), and as a medical transcriptionist - which she enjoyed until she was replaced by a dragon.

Her continued love of nature, gardens, Beale Street Music Festival and her pets compels her to take far too many photos, some of which she would like to share.

www.ingramcontent.com/pod-product-compliance
Lightning Source LLC
Chambersburg PA
CBHW080722190526
45169CB00006B/2476